The wonderful world of
DOGS

The wonderful world of
DOGS

CANDIDA BAKER

inspired
LIVING

ALLEN&UNWIN

First published in 2010

Inspired Living, an imprint of
Allen & Unwin
83 Alexander Street
Crows Nest NSW 2065
Australia
Phone: (61 2) 8425 0100
Fax: (61 2) 9906 2218
Email: info@allenandunwin.com
Web: www.allenandunwin.com

Cataloguing-in-Publication details are available
from the National Library of Australia
www.librariesaustralia.nla.gov.au

ISBN 978 1 74237 425 3

Internal design by Nada Backovic
Set in 13/18 pt Centaur BH by Bookhouse, Sydney
Author photo by Sam Drewe
Printed in Australia by McPherson's Printing Group

10 9 8 7 6 5 4 3 2 1

Mixed Sources

Product group from well-managed
forests, and other controlled sources
www.fsc.org Cert no. SGS-COC-004121
© 1996 Forest Stewardship Council

The paper in this book is FSC certified.
FSC promotes environmentally responsible,
socially beneficial and economically viable
management of the world's forests.

For Anna, who loves her puppy dogs

Contents

Introduction

Dogs, I sometimes think to myself, seem to have mastered the art of Zen. They appear to live purely for the moment with very little concern for what was, or for what will be. The world of dogs is—or should be—a simple one, with lots of food, love, walks and play. And yet, in this collection there are numerous stories that suggest our understanding of dogs is limited.

In this book you will find stories of dogs rescuing people from disaster, helping as hospice volunteers, showing immense bravery in the face of danger—dogs challenging our ideas of what a dog is or does. Of course, you will also discover stories of naughty dogs, cheeky dogs and silly dogs—and at least one of those has been owned by me!

Most of all, revealed within these pages is the best gift that dogs can give us—the gift of unconditional love. Even when dogs have been abused, neglected

or treated badly, their capacity to recover is astonishing, and their eagerness to please incredibly touching.

One of the unfortunate things about being a dog owner is that we tend to outlive our four-legged friends, and many of these stories are bittersweet. I'm very lucky to have been owned by some wonderful dogs in my lifetime, and have sadly lost a few. I think perhaps they have a lot to teach us about the importance of enjoying life while we are here, and about the process of letting go when we cross over. There are several touching stories in the book about dogs and their owners coming to terms with the dog's desire to leave its body, which have certainly helped me look at death in a different way.

It has been a pleasure to compile this book, and to read the wonderful stories that people have contributed. I've enjoyed every minute of it—as much as my puppy has enjoyed chewing up the proofs I accidentally left on the ground!

Candida Baker
June 2010

Acknowledgements

I have been extremely fortunate with both *The Wonderful World of Dogs*, and *The Infinite Magic of Horses*, to work with a wonderful team at Allen & Unwin. I would like to thank my publisher, Maggie Hamilton, for her inspirational wisdom, her kindness and her support; Jo Lyons for her tact, diplomacy and grace under pressure; and Liz Keenan for her careful and judicious editing. I would particularly like to thank Robert Drewe for allowing me to reprint several chapters from his book, *Walking Ella*. Thanks to Jacklyn Wagner, Lisa Burton, Guide Dogs NSW/ACT, and all those who supplied photos. I would also like to thank everybody who has contributed to the book—the response to my call for dog stories made compiling the book a rewarding experience. $1 from every book sold will be donated to Guide Dogs NSW/ACT.

'Dogs are miracles with paws.'

Susan Kennedy

Belle the Bold, the Brave and the Beautiful

We get them when they are eight weeks old. Three puppies—one boy and two girls—a brother and two sisters, King Charles Spaniel crossed with a Fox Terrier.

The Foxy mum, Lucy, belongs to my daughter's friend, Mia, and it seems as if Lucy is foxy by name and nature, managing a secret midnight tryst on New Year's eve with a handsome King Charles Spaniel when she had been due to be mated with a pure Fox Terrier later that week.

But Lucy had other ideas, and while her family was partying she was too. In due course she has four puppies, two boys and two girls, and in our house the pleading begins: 'Can't we have a puppy, Mummy, can't we, can't we?'

We had made the decision to put our old dog, Ella, down the year before, and Anna, my daughter, has obviously decided the mourning period is well and truly over.

So finally I agree, and to Anna's delight suggest that if we are getting one dog, we might as well get two so we won't have one small lonely puppy surrounded by a dozen large horses. Anna suggests three, but I know my limits and state firmly that there is no way I am going to have three puppies.

But that is before I see them, and fall in love with them. One has already found a home, so there are three left, and one of them is this darling white, black and grey long-haired ball of fluff, with the most endearing expression in her eyes I've ever seen.

So yes, call me a sucker, but eight weeks later, not one, not two, but three puppies come home.

Very quickly we find names for them. The boy, with his pale, longish fur and the faintest of beige patches, becomes Coco the Calm; the littlest girl, a black-and-white puppy that looks just like a Foxy and nothing like a King Charles Spaniel, becomes Molly the Mild; and then there is my little ball of fluff, Belle. Well, there is no doubt about it. Right from the start she is Belle

the Bold—and later, when she starts picking on her submissive sister, Belle the Bully.

When the puppies arrive I happen to be in a state of depression, suffering a massive dose of overwhelm from life, the universe and everything, but even though their toilet habits are nonexistent and their nuisance factor is off the scale, they give me a wonderful present—they make me laugh. Their antics keep me entertained for hours, and as they become bigger and stronger and start to take walks with me, and later to come out with me when I ride the horses, they begin to fit themselves into the pattern of our country life.

People say to me, 'Why three? You must be mad.' And there are times when I think so too, but mostly I am delighted to be surrounded by my three boisterous little friends.

Their early nicknames prove prescient. Coco the Calm becomes even calmer, his underbite showing a toothy little grin. He plays happily with either sister, but will quickly stop to sit on a lap and gaze lovingly into our eyes. Actually, we think he is a little 'blonde', but we give him the benefit of the doubt and call it calmness instead. Allowed in at night onto the sofa for cuddles, Coco immediately spreadeagles himself and falls fast asleep.

Molly the Mild becomes known as Fat Worm, due to her habit of eating anything she can find, and ingratiating herself with visitors who fall in love with her, wanting to take her home with them while we laugh and say, 'Sucked in by Molly, again!' When she climbs onto the sofa, she burrows her way into the nearest human and clings to them as if she is drowning.

But Belle, well—it seems as if Belle has attention deficit disorder. She hardly ever sits still, her boundless enthusiasm and energy leaving all of us exhausted in her wake. She jumps from lap to lap, full of glee and licks and love. For a small dog she is as fast as a bullet and unfortunately for everybody who lives in our lane, she develops a habit of chasing cars, which she then teaches to her brother and sister. We keep them in as best we can, but on acreage it's almost impossible. It seems inevitable that if I take them for a walk up the lane a car will pass me, and I will have to frantically try and scoop up puppies in every direction before they are collected by speeding wheels.

One day the NRMA man comes to the house next door, and drives down our communal driveway far too fast. Both Belle and Coco chase him, and he must have glanced Coco because I hear a commotion, and then Coco disappears for the rest of the day. He is more circumspect after that, but Belle remains undaunted, in pure Belle form.

For a brave dog, Belle is also very sensitive. She is the most eager to please humans, and she is a friendly top dog, delighting in meeting other dogs and flying up the lane to greet any stranger who comes our way. But she hates the odd hot-air balloon that makes its way over the hills at the weekends, and she quivers with fear at the sound of thunder, glancing up at the ceiling or sky with a worried expression while her more phlegmatic siblings take it all in their stride.

Our neighbour's dog, a Blue Heeler named Pugsley, takes to visiting us. He'd made our acquaintance shortly after we'd moved in and before we got the puppies, when his mistress, Katy, gave birth to her second son. Left alone in the house, Pugsley, a very independent chap, decides enough is enough and finding us at the end of the lane, quickly becomes a regular visitor. When the puppies first arrive he isn't too sure about the three balls of fluff that suddenly appear around his ankles, but pretty soon, he comes almost daily to visit his little friends.

One day a man who comes to try a horse brings a rather boisterous large young dog with him, and it worries the puppies. Pugsley steps right in, friendly but firm—inserting himself between the young dog and the puppies until the youngster gets the message he is to leave them alone. Pugsley likes to think

he helps. So he arrives to 'help' us feed the horses, or fill the water troughs or do the gardening. The puppies are under no such illusion and are more like small children, living in their tumbling, naughty, spontaneous world.

Sometimes when people ask me about why I have three, I say that it is a bit of an insurance policy, what with ticks and snakes and traffic and horses. But of course I don't really mean it. It is impossible to imagine life without my naughty tribe and it becomes pretty obvious that they are 'the puppies' forever or, on occasion, the Three Amigos, the Three Musketeers, or—when they have been particularly bad, bad, bad—Satan's Babies.

It doesn't take Pugsley and Belle long to realise that they are kindred spirits, and from the time Belle is about nine months old, they begin to wander, disappearing for so many hours into the neighbouring macadamia farms that in the end Katy curtails Pugsley's visiting rights. When he is allowed out, he makes a bee-line for Belle and it is almost impossible to be quick enough to stop them from heading off to explore.

Once Pugsley's visits are stopped, Belle has only her siblings to play with, but finds life somewhat boring without her wandering friend. When Anne and her Golden Retriever, Ned, move in at the top of the lane and take to walking down near our house, Belle is delighted. She throws herself, with her

usual affectionate energy, into having not one but two homes, trotting up the lane to Anne's house whenever she feels like it and bursting through the screen door to sit on the sofa and demand cuddles.

For her size she has an insatiable demand for exercise. I can walk the three dogs at first light, bring them home, give them breakfast and, before you can say 'knife', Belle will be off to walk with Anne and Ned. One day, riding around the lake with my friend, I spot Belle out with Anne and Ned, streaking through the grass on the opposite shore, her feathery tail on high, oblivious to the presence of her 'owner'.

But an owner is something you can't really be to Belle, and although sometimes I think perhaps I should curtail her freedom, I can't bring myself to do it. There is something so free about her, so completely in the moment, that it seems out of the question to lock her up for hours when I am at work, or even to keep her in all the time when I am at home. She roams the lane, visiting and saying hello to all her friends, and she shares her heart with all of them. It's often struck me that there are dogs, and then there are human-dogs, and Belle is a human-dog—her eyes full of expression: What next? Where now? She is the most trainable of the three, and will sit easily—the only time she is quiet—waiting for her dinner, her eyes fixed on me while

Coco and Molly tumble and tussle around us. Sometimes she seems almost telepathic.

On the occasions when I practise meditation late at night or early in the morning, I can often sense this channel of love between us. In many ways, she is everybody's dog, but she is also my soul dog, and we both know it. I recognise myself in her—it isn't too long a bow to draw to see that I can be brave and bold, quite often bossy, but often surprisingly sensitive, and if I have one over-riding trait it is my need for independence. So I know Belle as well as I know myself.

Almost.

Every now and then I spend a night away from the property. Arriving back on this particular morning, I find Belle and Coco at the top of the lane where it meets the road. I immediately deduce that they have been chasing cars, and I am cross with them. They follow me down the lane, and I notice that Belle is not as fast as usual, but I don't think much of it. It crosses my mind that perhaps she's had a little bump but she seems OK, if a little below par.

And then, for reasons that I still can't fathom to this day, I repeatedly ignore the signs of tick poisoning. I notice Belle has trouble getting in and

out of the car, yet I do nothing. When I go out, I put her out of the house even though she clearly—and unusually—doesn't want to go.

Later I will reason that the dogs had just had a tick bath only two days before, and their tick treatments had been kept up regularly. It doesn't even cross my mind that it might be a tick, which is strange because we all know that in the summer months ticks are the biggest risk to the dogs in the area. But the oddest thing of all is that I, who fuss over the slightest injury to anyone—human or animal—behave in such an uncharacteristically blasé fashion.

Finally my daughter Anna finds the tick that afternoon, but even before she can tell me, I've finally realised that there is something seriously wrong when Belle falls in front of one of the horses and can't get up.

I take her straight to my vet, Willa, who is concerned. She treats her as much as she can, but we both agree that it is best for Belle to come home with me, as she would fret in the dark alone in the surgery, but that I should ring Willa immediately if Belle starts to aspirate or vomit.

I bring her home and lay her on a towel in the corner of our sofa, and she stays there, weak but seemingly happy. When Anna and my son, Sam, go to bed, they both kiss her goodbye, just in case. I decide to sleep on the sofa with her and I lie at the other end, with my feet near her head. She wiggles

herself around so her head is on my feet, and we sleep for four or five hours together like that. Silently though, her lungs are beginning to cave in under the fluid created by the poison.

At 5 a.m., I am woken by a choking sound, and I realise at once that she is worse.

I quickly gather myself together and call Willa, leave a note for the children and drive to the vet's. Before I leave I almost open the door of the barn—where the puppies normally sleep—so Belle can say good-bye to Coco and Molly. But I think perhaps there is still hope and it seems to be almost jinxing her to do that, and besides I am in a hurry. She sits on the passenger seat beside me and I caress her all the way to the vet's surgery. She puts her head on my hand and gazes at me, and still seems so with me that I think she will be fine.

Willa treats her again, but I can tell she thinks there is not that much hope. Perhaps if I had realised there was none, I would not have left her there to die alone in a cage. I would not have kissed her little head and left her there. I would have brought her home so she could die on the sofa, surrounded by love.

In the afternoon, waiting to hear from Willa, I take the other puppies for a walk down by the lake, and as I am walking along one of the avenues of macadamia trees in the quiet, dark shade they provide, I notice a black-and-white feather on the ground. I pick it up and muse to myself that it looks like Belle's colouring. Not far away I spot another feather, this time brown and white and obviously from a completely different bird. For some reason, the image of a dog I had owned thirty years ago, a little brown-and-white Fox Terrier called Sleepy—who was anything but—pops into my brain.

When I get home about five minutes later, there is a message from Willa asking me to ring her.

I call her back with a heavy heart. I know already—if it was good news she would have said so.

Belle, Willa says, had died five minutes earlier, her lungs not able to take the pressure of the fluid. She had died at exactly the time I had found the feather.

I am devastated. Willa and I both cry on the phone, and then I have to face the task of telling Anna that her doggy is gone. She is playing with her friends, and she knows as soon as she sees me that something has happened.

We collect Belle's body while she is still warm, and we lay her on a rug on the grass and the girls come and stroke her and cover her with flowers.

We wrap her in a rug with a chew toy for the next world, and we cover the rug in kisses. We dig a grave in the garden, and before we walk her to her resting place, I show her to Molly and Coco.

They come straight up to her, and then immediately back off, tails between their legs, ears flat—and I know they know that Belle is gone. For some days afterwards, the two of them, particularly Molly, somehow connect me with Belle's disappearance, and shun me as if I have done something dreadful, which only worsens my feeling that I have done something dreadful!

We bury Belle in the garden, and over the next week or two we surround the grave with bricks, and make her a beautiful wooden cross on which we solder her name and numerous love-hearts. I am sitting at my kitchen table as I write this, and I can look out the window and see the children on the swing under the old fig tree, straight across the paddock to the line of bottle-brush trees where Belle is buried.

Sometimes in the past after losing a pet, I have felt it near me—one of my cats jumped on the bed for months after she died, so psychic phenomenon is not unknown to me. I haven't felt Belle, as so much seen her with my little

dog Sleepy, which still surprises me, although when I express surprise that Sleepy should still be in spirit form after all these years, 'they' reply that she may even have been back and come back again to the spirit world. I never once thought that Belle was Sleepy reincarnated; Sleepy was far too well trained and well behaved to come back as my boisterous bully. But the idea that they might be together now comforts me.

It's changed some things, life without Belle. To begin with, it's quieter.

For Molly life has improved dramatically. Without Belle relentlessly on her case, she can move through life much more sedately. And yet . . . both she and her brother have lost their 'lead' dog. When we walk up the road at night now, they are afraid of their own shadows, and sometimes they look at me as if to ask when Belle is coming back, and what on earth I've done with her.

Pugsley is allowed back down for visits now that there is no more wandering, and when Molly and Coco have to concentrate all their energy on keeping up with the horses, I sometimes feel that Belle is there with us just as fast as ever.

It is a strange thing that the illness, death and absence of a small dog can be so upsetting, but as a friend once said, they're not called family pets for nothing. They are part of the family.

Belle was part of me, and I was part of her. I do believe that we are all part of a loving energy, and Belle is back within that energy now. It makes her no less a part of my life, it's just in a different form.

It is the idea of Belle resting in peace that makes me feel better about her absence from our lives, because when people say to me, Well, she's at peace now, I stop and pause and think, How could that possibly be?

Wherever she is now I am sure Belle is just as much a whirling Sufi dog in the afterlife as she was in this life.

Rest in energy, Belle!

Candida Baker

'The great pleasure of a dog is that you may make a fool of yourself with him and not only will he not scold you, but he will make a fool of himself too.'

Samuel Butler

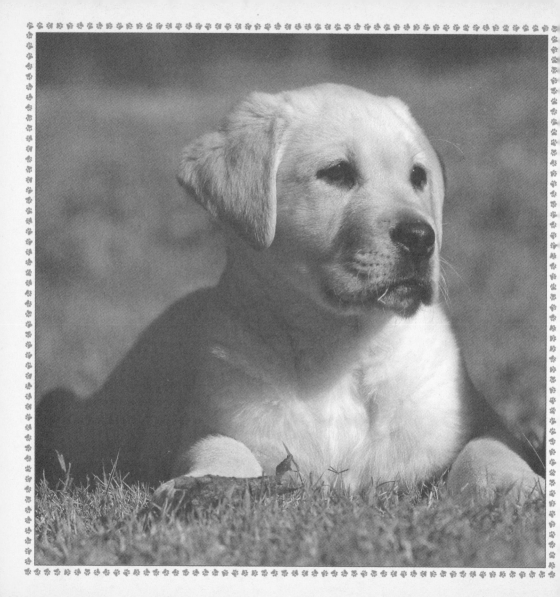

Ollie Finds a Home

One busy Saturday morning, I was on a shopping expedition with my five-year-old son Hugo when we saw a beautiful Labrador loitering outside a fast-food shop.

This, I told Hugo, was the kind of dog we were planning to get for the family when we moved from our apartment to our new house. We followed the dog at a distance as he made his way down the street, stopping to drool at the entrance to every food outlet!

He seemed very friendly but had no identity disc or collar, and when he tried to cross the road at an extremely busy intersection I decided to take control.

Without much coercion, he followed us to the car, jumped in and we headed home!

I phoned local vets, the RSPCA, the pound and any other organisation I could think of, but no one had reported a missing dog.

Ollie immediately connected with our family and after a week it was a veritable love affair. Just over a week later, the phone rang and it was an American lady telling me that apparently I had her dog. She described Ollie—known to her as Carl—precisely. She said she travelled a lot and the dog would often wander into the shopping centre looking for company—and food! I berated her in a very angry and tearful manner and accused her of all sorts of neglect of such a beautiful dog. But nevertheless he was her dog, and he had to go home to her.

My husband would not allow me to come with him for the 'drop off' because I was in such an emotional state. There was another reason as well: he wanted to ask the owner if she would sell Ollie to us.

Half an hour later, my husband phoned to say that the American lady had agreed. She had said to my husband she would like us to have Ollie as we obviously loved him so much, she believed he would be happier with us.

Ollie died last year after thirteen wonderful years with us. He was without a doubt the most loyal, beautiful companion my family and I could ever have wished for. Thank you, American lady!

Ruth Gotterson

'One reason a dog can be such a comfort
when you're feeling blue is that he
doesn't try to find out why.'

Anonymous

Faithful to the End

In 1924, Hidesaburo Ueno, a professor at the University of Tokyo, brought his beautiful male Akita Inu, Hachiko, to live with him in the city.

Every morning, Hachiko saw his master out of the front door, and every evening he met him at Shibuya railway station. The routine continued for over a year, until one evening in May 1925 when Professor Ueno suffered a heart attack and did not return on the train.

After Professor Ueno's death, Hachiko was given away, but he kept escaping and going back to his old home, until finally he seemed to realise that his master no longer lived there.

Hachiko then took up a daily vigil at the station, waiting for his missing master. This gradually attracted the attention of the other commuters, many of whom had seen the professor and his beloved dog together.

As the days went by and still Hachiko waited for the professor to return,

more and more people started to notice the beautiful dog. They brought Hachiko food and treated him like a prince.

For nine years Hachiko went to the station each evening at exactly the time when the train was due. Finally he died on the steps, at the very spot where he used to meet his master.

At one point, one of Ueno's former students heard about the dog and became intrigued by his story. He decided to conduct a census of the Akita breed, and found that Hachiko was one of only thirty pure-bred Akitas remaining in Japan.

The student went often to visit Hachiko and published several articles that brought Hachiko to the attention of the national media. Hachiko became a sensation. His fidelity to his master's memory became a legend, and teachers cited him as an example of family loyalty.

A sculpture of Hachiko was erected near the railway station, and the Japanese people once more embraced their own Akita breed. Hachiko's stuffed and mounted remains are kept at the National Science Museum of Japan in Tokyo. The statue, which was melted down for metal during World War II, was re-created after the war and is now a popular meeting spot.

Candida Baker

'Dogs have given us their absolute all.
We are the center of their universe. We
are the focus of their love and faith and
trust. They serve us in return for scraps.
It is without a doubt the best deal man
has ever made.'

Roger Caras

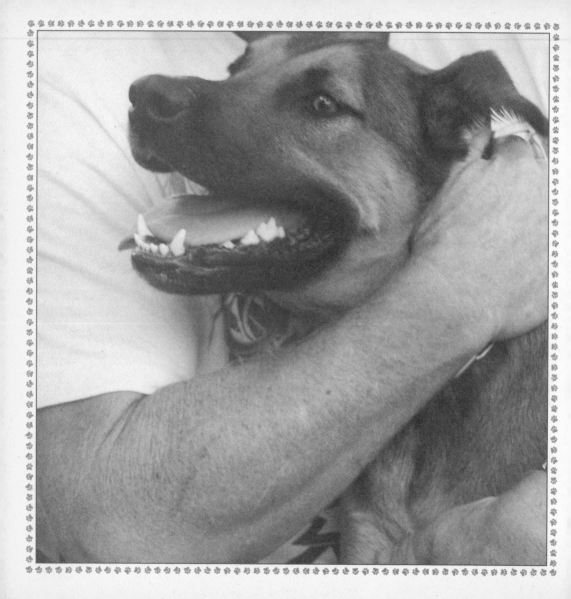

It Pays to be Prepared

Several years ago, I agisted my horse in a paddock that was tucked away in the heart of a suburban residential area.

This paddock was less than a kilometre from my home and one morning, rather than drive there to feed my horse, I decided to walk with my dog, Kell, a small Kelpie-cross. Once the feeding and rugging had been done, I went into the stables, picked up a shovel and a feedbag which I needed at home, and headed off.

Halfway home I came across a man who was walking towards me with his very large Labrador. Living in an area populated by environmentally responsible citizens, he was holding a small plastic bag in his right hand ready to collect any droppings his dog might deposit. He looked at me, saw the shovel over

one shoulder and the feedbag over the other, looked at little Kell, and said, 'Gawd, for a dog that size, you sure are prepared!'

David Faen

'If you are a dog and your owner
suggests that you wear a sweater,
suggest that he wear a tail.'

Fran Lebowitz

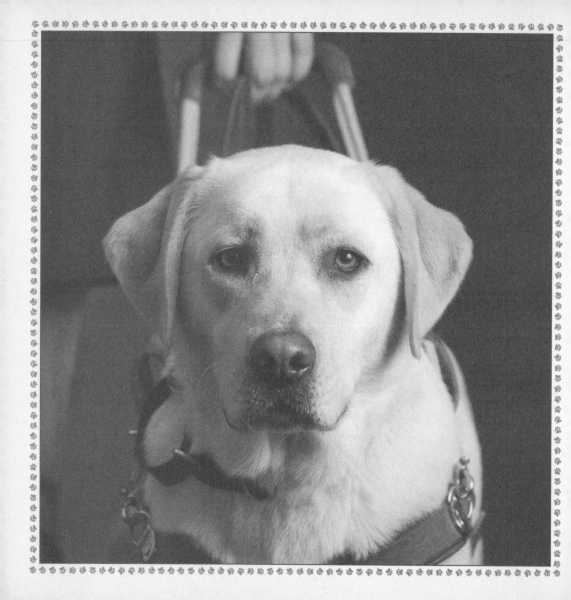

Mutual Rescue

Burglary. The word is as unattractive as the crime it refers to.

Still, with any luck it remains comfortably remote, the stuff of newspaper headlines, unless it happens to you.

My Labrador guide dog, Dori, and I were out at work the day our home was invaded. The discovery that evening that someone had broken in was far more chilling than the winter wind blowing through the smashed windows. I was rarely home before seven o'clock in those days, and my husband Chris's job was four hours' drive away in the city. He bivouacked in a tiny flat, coming home for weekends and holidays.

The police were wonderful, offering a comforting blend of sympathy and practicality. There were questions; a swift, consoling hug and efficient wielding of the vacuum cleaner to protect unwary paws from shards of broken glass. Chris drove home for the night and the glazier was booked for the next

morning, but it wasn't enough. I felt vulnerable and violated. I needed a friend, I decided, who could be at home when Dori and I were not.

The inspiration, when it came, felt like a gift from heaven and perhaps it was; lying in bed, horribly conscious that a stranger had been through our possessions, I made my spontaneous declaration: 'I want a German Shepherd.' To his eternal credit, my forbearing partner did not demur. If you have ever lived with the much-maligned German Shepherd or Alsatian you will know just how wonderful they can be, despite their fearsome reputation. I grew up with three and have always loved them.

The rightness of our decision to adopt another dog was unwittingly confirmed the next morning by the glazier; ours, he said, was one of fourteen break-ins that had occurred in one afternoon and his services were much in demand. He told us that the only houses spared were those where there had either been a person or a canine in residence. The die was cast.

One of the best things about working in radio is that you make countless friends, many of whom you never meet. While the putty was still drying around our sparkling new windows I made time at the office to ring the RSPCA.

The previous day I had interviewed one of the local managers about snakes. He was a proficient but reluctant guest, one of those glorious characters who much prefer animals to people, so when I left a message I made it clear that I needed his help. It worked; he rang back and immediately took my problem seriously. The only question he asked was, 'Are you sure about the breed?' When I said yes, he declared that he would put the word out to all the managers and told me that he would find me something special.

At about the same time as our domestic drama was happening, a two-year-old German Shepherd named Allie was in serious trouble. Brought up in a town, Allie had recently moved with her family to a village, where they had built a house. Unfortunately, their property bordered a sheep paddock; the fencing was inadequate and the result inevitable. The chased ewe gave birth prematurely and, although she and her lamb were unharmed, the farmer issued the traditional warning: if it happened again, the dog would be shot on sight. Allie was tied up, the decision made, and everybody cried.

Yes, you guessed it. The RSPCA put the family in touch with us, calls and details were exchanged, and less than two weeks after the burglary we devoted a Sunday to meeting Allie. We did not expect to be bringing her

home the same day, but that is what happened. This thin, hyperactive, sandy-coated whirlwind won us over the moment she bounded up to us.

One skill you must learn as a guide-dog owner is that of bonding with a new dog. Forming that indissoluble 'You and me against the world' connection is crucial to any working relationship, and we used the same techniques with Allie as we had with Dori, talking to her constantly, involving her in whatever we were doing, singing songs and telling stories with her name in every line. When walking through the house I would stop to pat her if our paths crossed; she soon grew wise to this and would roll over on my feet to make sure I noticed her. She still does it to this day.

Allie's health was our first concern. We wormed and bathed her on that first night and when drying her could not fail to notice her lean and hungry look. A vet check confirmed our suspicions of a pancreatic deficiency, an inability to extract the necessary nutrients from food. However, in general her health was good and we were delighted with the overall verdict: 'This is the best-natured Shepherd I have ever seen.' Who were we to argue?

The amazing thing about the medication prescribed for pancreas deficiency is that not only does it supply the enzymes the body cannot provide for itself, but in some cases it can also kick-start the body's own system into enzyme

production, thereby rendering itself redundant. This happened with Allie. We also began adding small amounts of a stock-feed supplement to her meals, learning later that by sheer coincidence this contained all the vitamins and minerals prescribed by natural therapists when treating this condition. We still use the supplement today and, stealing shamelessly from A.A. Milne's Kanga and baby Roo, call it her 'Strengthening Medicine'.

Less than a year later, I discovered a lump on Allie's side, an abscess that had been growing steadily for months but which was barely visible above the surface of the skin. She recovered rapidly from the surgery, doing a creditable imitation of the howling Hound of the Baskervilles when she woke from the anaesthetic and virtually wrecking her huge plastic Elizabethan collar by crashing through the garden and furniture alike during her convalescence.

Although she's had other health crises, including an infected mouth from eating too many bees, today Allie is beautiful, with a luxuriant red-and-black coat, warm hazel eyes, and a sweeping tail that would put any fox to shame. She has acquired many names over the years, including Allie-Bear and these days she is often just called plain Bear. She answers to them all.

What of guide dog Dori, I hear you ask. How did she cope with the interloper? They were never close, truth to tell, though they tolerated each

other enough to curl up together for warmth and one would show concern if the other became ill or upset. We treated them equally when they were together and made much of them separately when apart. Dori had seen me through a serious illness three years before Allie's arrival and it was after Dori died unexpectedly that Allie took on the mantle of emotional guardian. The sudden loss of a guide dog is traumatic, and I was a wreck. Allie literally howled with me when I cried; she lay on the bed beside me, allowed me to hand-feed her treats that she ate as much to please me as herself, and since then has responded immediately to my every mood.

Then came Rosi.

Rosi is my third guide dog, a shiny black Labrador. Her work is stellar, her zest for life infectious and inclusive. Within weeks of her arrival she taught Allie how to play and she takes on the role of class clown should anyone be worried or unhappy. Unlike most Labradors, Dori hated water and was terrified of squeaky toys. Rosi and Allie have a passion for both; the beach is their favourite place, and Allie is a virtuoso on the squeakers.

Acquiring Allie-Bear, our beloved Shepherdess, is one of the best things Chris and I have ever done, second only to our decision to marry and mine to apply for my first guide dog. Shepherds are gloriously vocal and interactive,

and Bear even tolerates my feeble attempts to commune with her in German. Chris has not commuted to work in the city for some years now, and 'the girls', as we call them, love it when we're all at home together. If there was a silver lining to our burglary cloud, it has pointy ears and an astonishing capacity for unconditional love—the perfect shape for a happy ending.

Elaine Harris

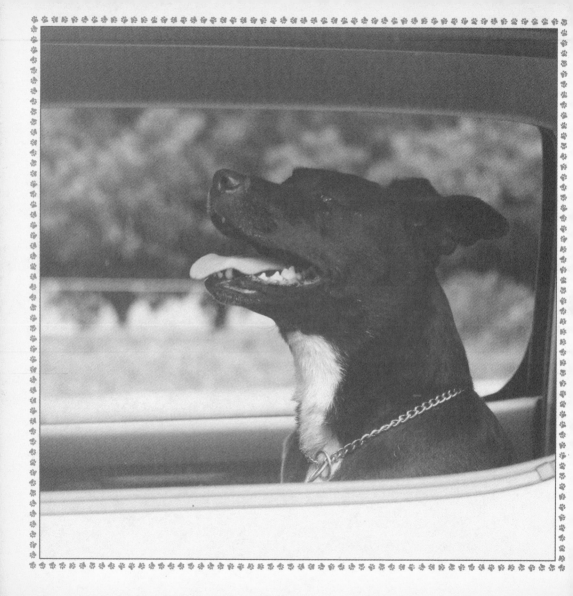

Murder Most Fowl

In the early days of our marriage, my husband and I acquired child substitutes in the form of a pair of Irish Setters. Mick and Kelly were gorgeous, with rich mahogany coats and warm brown eyes. Their personalities were also appealing—they were loyal and affectionate although, like the rest of their breed, they were not overly endowed with intelligence.

We would often take them to the farm where I had grown up and where my parents still lived. There were 100 acres of rolling green hills to explore, and three dams in which to swim.

One Sunday afternoon, we made our customary pilgrimage to the property. A newly hired farm manager and his family had recently moved into the small workers' cottage next door to my parents' home. This particular day, the manager's wife, who had entered the Lovely Motherhood Quest, was holding

an afternoon tea-party in the grounds of their cottage and the quest was a fundraiser for a worthy charity.

The little gathering next door was in full swing when we arrived. Ladies in high heels, pretty frocks and hats dotted the lawn, cups and saucers in hand.

It was with some horror that my husband and I spotted Mick in the paddock that separated the two houses. He had slipped under the barbed wire and was silently stalking the free-range chooks belonging to the new neighbours. He was frozen in a classic pointing stance, nose and tail extended and one front paw drawn up, completely focused on the closest fowl. He could well have been posing for a hunting print or a scene destined to be pressed in brass for a fire screen.

Oblivious to our hushed calls, he homed in on the unaware hen. I was debating whether to vault the fence and grab him when one of the tea-party guests spotted the little tableau and screamed, 'Oh my God, look at that dog . . . it's after the chooks!'

With that, the entire flock bolted. The targeted hen looked behind, saw the danger, and started screeching, running along the ground, flapping its puny wings and making valiant but inadequate efforts to take flight. Mick snapped out of his trance and swooped on the poor bird. In one graceful movement,

he grabbed it mid-squawk and performed a 180-degree manoeuvre that brought him back to us. Accompanied by shrieks of 'Fluffy! Oh no, the dog's got Fluffy!' from the neighbours' children, Mick shot through the wire fence and gently laid the bird at my husband's feet.

The hen was in pristine condition, with not a feather out of place. Unfortunately, it was also quite dead, presumably from a chook-sized heart attack.

Much grovelling ensued, with wallets produced and cash pressed into angry hands. Threats were made, apologies also. The background noise of bawling kiddies added to our general feeling of discomfort.

The thing was, though, we knew we couldn't punish the dog. For one glorious moment, pure instinct had taken over, and Mick had performed a task imprinted in his tiny brain by generations of careful breeding. He retrieved a bird and delivered it unmarked to his lord and master. Unfortunately, the middle section of his duty had eluded him: the part where the intended target was shot first. That small detail notwithstanding, Mick couldn't have been more pleased or proud—and secretly, neither could we.

We never did take him back to the farm, though.

Maggie Cooper

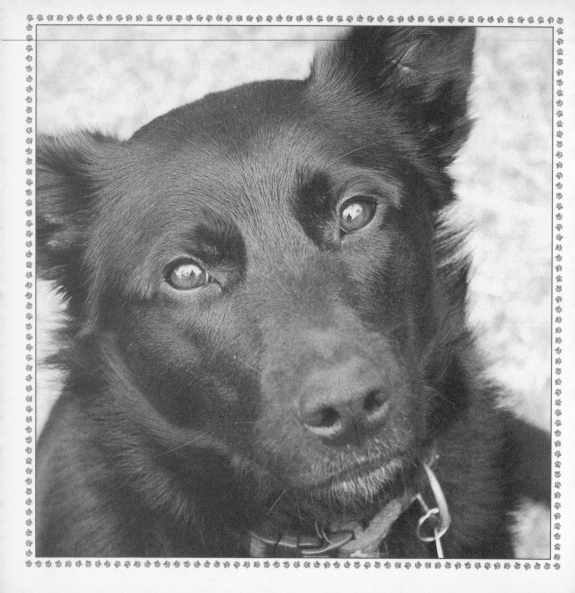

Our Lovely Labradors

I've known a lot of nice doggies in my time, but my first memorable encounter with the K9 variety was when my family lived for a time at my grandparents' small farm in the Hills district outside Sydney. 'Wingello' was home to creatures large and small, even a flock of racing pigeons.

My Nana Mon owned a trio of Labradors, which she'd shown with great success. They had won many prizes at Sydney's Royal Easter Show and were also used as breeding stock and the choice pups of each litter were sent to Western Australia to be trained as guide dogs for the blind. I still have the photos my parents took of the Labs hanging around my playpen, and I guess this is where our connection developed.

Once I got outside the confines of my pen, at the mighty age of three, my firm friendship with the Bow-Wow took hold—after all, they seemed less threatening than the larger, hoofed creatures on the property, and more

interesting than the mindless chooks, who had no time to spare for a tiny tyrant in a singlet and gumboots.

My favourite was Jeddah, the old black bitch with big black floppy velvet ears, but I also loved the Golden Girl Jenny, with her big soft blue eyes and brown nose. Old Henry, the male dog, didn't do much other than sleep and eat, and occasionally perform his matrimonial duties with his wives.

I have vivid memories of evicting the dogs from their kennel so I could take up residence or hold a tea-party in their lodgings, and I wonder now about the level of adult supervision—or lack of it.

The mud pies I made from the dogs' drinking water were very entertaining, but I was offended when the doggies wouldn't eat them. I would also wash the dogs in mud, much to the horror of the grown-ups. The Labs made great substitutes for ponies and were much less threatening than the real McCoy. Poor old dogs, it's a wonder they didn't get sway backs and hip dysplasia, but I guess I was a small specimen, the runt of the litter, you could say.

I remember old black Jeddah standing there patiently with a sand bucket under her belly while I milked away at her droopy under bits, mimicking Pa Arthur milking the cows.

We would also receive visits from two male mystery dogs who were also golden Labradors and no doubt hoping for a date with Jeddah or Jenny. The fact that both were confined to their compound when they were in season did little to dim the eager suitors' enthusiasm.

We learned that the mystery dogs were named Winston and Boson and that to reach us they had to track for miles through the paddocks from the local poultry farm. Winston would take up permanent residence for the duration of our females' season, even sleeping on the back verandah.

Early each morning Pa Arthur's ritual would be to take his walk to the front gate, a fair distance from the house, to collect the *Sydney Morning Herald*. One morning Winston went along for the stroll and after that took it upon himself to religiously collect the paper and place the hefty gift at the back door—albeit with complimentary teeth punctures in the first section. When Winston finally decided to return home, we learned he would do the same for his owner; he would also carry baskets of eggs—without dropping any— for the chook man. When the dogs were in season again, Winston would return and resume collecting the newspaper.

Boson, his partner in crime, was a different kettle of fish. Boson would return home to the chook farm each sunset, but never empty handed (or

mouthed) and usually with a gumboot or boot that we had left at the back door, much to everyone's annoyance. It was not unusual to see family members getting about the place in odd boots. Years later when the old boot box was emptied out, there must have been thirty odd boots without their pairs in all shapes and sizes—each living in hope its companion would return.

I still wonder what on earth Boson did with all those gumboots.

The most fascinating experience for a little person was the thrill of watching the wonder of birth. My dog friend Jenny had her whelping box set up inside the back hall entrance, under the coat rack. Little did I realise these tiny, squirmy blobs that didn't see and only seemed to suckle and sleep would, in a few weeks' time, turn into the charging Light Brigade and I, too, would be a member.

One particular day the mischievous lot somehow broke through their barricade and galloped straight down the hall. Those puppies wreaked havoc in the two-storey stately home. They played hide-and-seek and tug-of-war with the dining-room drapes and then ventured into the lounge room where they decided to have some fun on the big old feather-filled lounge suite.

When the adults arrived there were puppies and feathers everywhere, along with the odd ornament that had fallen and smashed during the onslaught.

I still remember the horror on the grown-ups' faces! The puppies were sternly defeathered and banished to the kennel and dog compound. After the house was cleared of evidence of 'the bad puppy affair', it was a case of 'Has anyone seen Arthur's Homburg hat?' Everyone looked high and low, until somebody found one lone puppy peeping out sheepishly from under the sideboard. Between his paws lay the hat, chewed to pieces.

It was hard to believe these mischievous pups would eventually become guide dogs and loving, dedicated companions for the blind.

There was a permanent reminder of the 'puppy incident': mysterious yellow circles the size of saucers dotted about on the olive-green carpet.

Tracey Higgins

'I talk to him when I'm lonesome like;
and I'm sure he understands. When he
looks at me so attentively, and gently
licks my hands; then he rubs his nose
on my tailored clothes, but I never
say naught thereat. For the good Lord
knows I can buy more clothes, but never
a friend like that.'

W. Dayton Wedgefarth

Not a Clever Dog

Long after the Labradors had passed over, Nana Mon acquired a couple of Pembroke Corgis, the same breed that trot around with Queen Elizabeth.

Foxie and Pammy were nice enough dogs, both blessed with beautiful natures, and they came into my life about the same time my horse craziness was gaining momentum.

Foxie was the cause of a hugely embarrassing moment in a child handler class at a large dog show—he rolled over for me to rub his belly and would not budge! What was more infuriating was the fact he could strut his stuff blindfolded, and with his regular handler he had taken out big prizes at the Sydney dog show.

Dogs took second place for a time while I concentrated on horses. The next encounter with man's best friend was on the day old Pa Arthur arrived

home with a bounding, boisterous, brown-spotted, yellow-eyed maniac, aptly named Dalrello after a famous racehorse.

From the day Dalrello the Dalmatian arrived, he was full speed ahead—not an ideal animal to have around a farm, particularly if he was on the loose, which he would manage frequently.

One day Dalrello decided to chase the horses for entertainment, and of course the horses were spooked at the sight of the spotted maniac charging at them. I had horrible visions of horses galloping into a fence, and it was mayhem until one horse spun around and—whack!—the horse booted the dog in the side.

A little worse for wear, Dalrello was toted off to the vet's and one massive vet bill later he was back home in no time, all strapped up and plastered, with a bucket on his head to make him look even sillier than he already was.

This event took the wind out of his sails for a short time but it wasn't long before Dalrello was back to his senseless antics. His next target was the huge Friesian bull Stately Monarch, but there was no way this massive animal was going to be threatened by a lunatic with spots, and Dalrello was subjected to a good trampling. He fared better than he had after the horse incident but nonetheless he was sore and sorry for himself.

My last memory of Dalrello's wrongdoings is an image of him jumping up to grab and swing on Pa Arthur's white business shirts which were flapping in the wind on the clothes line. Dalrello flew around while gripping the shirts in his teeth and the washing line spun around like a carousel. The shirts were so ripped to shreds it looked as if he was having a go at maypole dancing. We all rolled around laughing. Pa Arthur was the only one who didn't see the funny side.

It wasn't long after this that Dalrello disappeared; he simply just vanished but his name sure didn't. A few years later, when my grandparents were going through a bitter divorce, Dalrello's name was cited during the divorce proceedings to demonstrate Nana Mon's lack of care with laundry.

I've always wondered what happened to him, but I knew instinctively it wasn't a good idea to ask because I might not have liked the answer. Good old Dalrello. For all his wrongdoings, he was a lovely dog.

Tracey Higgins

When I Was Very Young

When I was born and I came back home from the hospital with Mum, a big brown dog was there, and her name was Ella.

Mum tells me she used to lick my head when I was a baby, and as I grew up Ella played games with me. My brother used to dress her up in pirate trousers and play all sorts of games with her, even using her to pull along his skateboard. Although she was big she was always gentle and kind to everyone. She made all of us feel happy.

One night after I had finished dinner, I went out on the verandah with Ella. She was making this strange howling noise right at the moon, and it sounded like 'Owen, Owen.' I said to her, 'Who's Owen?'

Mum and Dad laughed, and ever since that night we always used to say, 'There's Ella calling for Owen again.'

She loved food and always begged for it with her puppy-dog eyes by the dinner table, and she would just about eat anything.

When I had a rabbit, Ella would pick him up by the neck and carry him around as if she was his mother. Rascally was allowed inside, and often he would jump around the living room and try and get Ella to play with him.

As Ella got older her hips started to hurt and she would often fall down. A few years ago, when my Dad took me and my brother to Sydney, I got a phone call from Mum to say that she was going to have to have Ella put down because she had fallen down the stairs and hurt herself, and she couldn't walk properly or get to her food bowl, so Mum knew she had to go.

Mum told me she let Ella eat lots of chocolate and baked beans on her last day! Ella was buried in a pet cemetery because we weren't sure where we would be living and we wanted to be able to visit her. When I got home from Sydney we talked so much about her, and did ceremonies for her. A year later, we went to where she was buried and we stood over her and prayed.

And that was the story of my first dog, Ella.

Anna Drewe

'The bond with a true dog is as lasting
as the ties of this earth will ever be.'

Konrad Lorenz

Patsy and Skippy

When I arrived at the alcoholism treatment centre, I felt hopeless, and was full of self-loathing. My drinking had got out of control and, after an intervention by my family, I was sent to a treatment centre many hours away from home for rehabilitation. That is where I met Skippy.

I was sitting out on the patio with the other women who were in rehab with me, when I noticed a dog lying in the grass. She was emaciated, large chunks of her hair were missing, and she had pus coming from her eyes. When I asked the women where the dog had come from, they said: 'Oh, she's just a stray. Don't go near her. She probably has all kinds of diseases.'

I never considered myself an animal lover, but I was drawn to this dog. I went over to take a closer look at her and when she looked up at me, I saw in her eyes the same despair and pain that I was feeling. I reached down to pet her and I felt a deep spiritual connection. Instinctively I knew that this

forlorn, sick animal and I would heal together. I felt a love and connection with this dog unlike any I had ever felt. The faintest glimmer of hope came into my heart.

Alcohol rehab was a lot of work. I was not quite sure what to expect but quickly discovered that each day was full of required activities, including group therapy, individual therapy, homework assignments as well as grocery shopping, cooking meals and going to AA meetings. The one good thing about this hectic schedule was that time went very fast—and another good thing was that in between all my activities I got to know Skippy.

I think she knew immediately how drawn I was to her. I started feeding her healthy meals, giving her baths and simply loving her. She responded to all of this loving treatment and in a short time, she wanted to be with only me. I began to feel that unconditional love that dog owners speak about. When I would come home after going out for a while, she would run to greet me, her tail wagging, and cover me with kisses. Of course, my heart melted. I would hold her, hug her and tell how much I loved her.

During the first few months, I had become friends with Heidi, one of the women who had just completed her treatment program at the rehab centre. She was a veterinarian and had just returned to work after her time in rehab.

She had watched Skippy and I grow and heal together. I knew Skippy was getting so much better, but I also knew that it was important to take her to the vet to get her checked out.

Heidi offered to see Skippy in her office and give her a complete check-up. When all of the tests were completed, Heidi called me with the results. I knew immediately from the sound of her voice that things were not good. She told me that Skippy had stage 4 heartworm. She explained that the worm had invaded Skippy's whole body and that a dog rarely survived when the disease had progressed this far. There was a treatment but Heidi feared that Skippy would not survive it. Skippy would have to be injected with a poison that would kill the worms, but the poison would spread throughout the rest of her body as well. She explained that Skippy would get very sick during the month-long treatment.

I told her to go ahead, but I was sick inside. I was so worried that I had made the wrong decision. I was worried that Skippy would die. But as the days passed, I knew intuitively that this was the right thing to do and I was determined to be with Skippy throughout the ordeal that was ahead.

The day that Skippy started the treatment was the beginning of the longest, hardest month of my life.

She was kept in a cage at the vet's surgery. I arrived early each morning, crawled into the cage and held her in my arms. In the beginning, she was so weak she could barely lift her head. I would look into those beautiful brown eyes of hers and tell her how much I loved her and that I would never leave her. In my heart, I knew she understood me. At the end of the day, the office assistant would tell me that it was time to leave and that they really had to close the office. Each day it was so hard to leave Skippy, but I would reassure her that I would be back in the morning—and every morning I came back.

There were many days when Heidi thought Skippy would not make it. It tore at my heart to watch her. She was so weak she did not even seem able to open her eyes. She would lie in my arms, totally listless, but after a few minutes she would open her eyes and then I would see all her courage and all her love for me.

During the third week, while I was sitting in the cage holding her, her tail started to wag. At first, I thought I was imagining it. I looked down and hoped that it would happen again. And it did. Skippy wagged her tail a second time, and then a third. I called out for Heidi, who came running in and immediately took Skippy's blood pressure. Sure enough, it was finally stable.

Tears ran down my face as I held Skippy and told her that I knew she could pull through this. The entire office staff were so thrilled—they were laughing and crying at once. It seemed like an absolute miracle!

By this point, Skippy and I had become inseparable and our healing journeys were completely intertwined. As I continued to recover emotionally and physically, so did Skippy. Two weeks after she wagged her tail, she sauntered out of the vet's office and came back to the rehab centre with me.

Every day she walked with me to my meetings and lay in the courtyard until it was time to walk 'home' together. She slept in my room at night. Her hair grew. Her eyes improved. She became an absolutely beautiful dog with a full shiny coat, the most expressive brown eyes and the sweetest disposition. Most people who had known her could not believe she was the same dog!

All this time, Tex, Skippy's 'owner', was living four houses away. His idea of taking care of a dog was to throw table scraps out into the yard when he thought of it. His yard was an unbelievable mess. The grass was overgrown; there were many dying shrubs and the front yard was full of garbage, including pizza boxes and more beer cans than I could count. He drove an old truck and drove with no caution, whipping around the corners as fast as he could.

He knew I was the person responsible for Skippy's dramatic change, but he still displayed no more interest in Skippy or her welfare than before.

By now I had been at the rehab centre for nine months, way beyond the average stay. I was a tough case! My counsellor began to discuss the possibility of my going home. I suppose I should have been happy, but all I felt was fear. This treatment centre had become a safe place for me and I was not sure I was ready to go back to the real world. So my counsellor recommended that I go home step by step, and encouraged me to return home for one weekend visit to begin with.

My husband and I had a good weekend, but it was as if we were both walking on eggshells. He was obviously afraid I would drink and was not quite sure how to relate to me. I was not sure how to act either. I also knew that alcohol was at the local store, only minutes away, so the weekend was tense. However, I considered it to be a success because I stayed sober.

My counsellor was pleased. She felt it was time for me to begin making serious plans to return home and re-start my life. She and I also had a heartfelt discussion about Skippy. I told her that I simply could not return home without Skippy. And she agreed. She said she was sure Skippy and I were

meant to be together for the rest of Skippy's life. So the next day I booked our tickets home to Virginia.

I was given another weekend pass before I returned home, this time to visit my parents, who lived a couple of hours' drive away. When I left for this weekend, I gave the other women clear and very detailed instructions about how to take care of Skippy.

When I returned to the centre two days later, I did not even bother to take my bags inside. I just ran around to the backyard looking for Skippy, but all I could see was the women sitting on the patio, looking very serious. When I noticed that Skippy was not there, I immediately sensed that something was wrong. I asked where Skippy was and no one answered. My heart stopped. Finally one of the women said, 'She's gone.' For a split second, I felt absolutely terrified and then I screamed: 'What do you mean she's gone?'

Before anyone had a chance to reply, my mind jumped back to a moment two weeks before when Tex had yelled out from his battered truck to one of the women, 'You're not doing a bad job taking care of that damn dog, are you? I think I might just take that dog back home with me.'

Within a few seconds, I found out that my worst fear had come true. The night before I came back, the women had forgotten to bring Skippy in. She

went out of the backyard and wandered around the neighbourhood. Tex saw her, grabbed her, took her back to his house and locked her inside.

Never in my life have I felt such desperation. My Skippy was gone! She had brought me back to life, and I had brought her back to life. Now we were separated—maybe forever.

I immediately ran over to Tex's house. I could see Skippy through his window. Her paws were up on the windowsill as she stared out at me. I ran all around the house. No one was home. Everything was locked tight.

How could this have happened? Skippy and I were scheduled to leave in forty-eight hours to go home together. I had no idea if Skippy would be with me on that flight and I felt utterly helpless. To stand outside staring at her through the window, locked in and looking so forlorn, gave me pain that I did not think I could bear.

An eternity seemed to pass while I waited for Tex to pull into his driveway. He was a very tall man and I walked right up to him, looked up and, trying to hide my desperation, asked him what was going on.

Skippy looked 'darn good' now, he said and he wanted her back. I stared at him in disbelief and tried to hide my trembling lips. How could he forget

that I had taken care of Skippy, that I had nursed her back to health over the last nine months, while he had simply abandoned her.

Out of nowhere I heard myself telling Tex that I was returning home to Virginia in two days and wanted to take Skippy with me. He answered, 'Well, it sure looks like that dog is goin' nowhere. She's mine now and you'll never get her back.' I turned around and walked back to the centre in a state of shock.

When I got back to the house, I fell on my bed and sobbed. I could not see any way that Skippy would be in my life again. All I could do was pray that God would somehow see me through this nightmare because I knew that Skippy and I belonged together.

Just then my sister Maryanne called from Australia. When I said I couldn't take the call, my roommate told her what had happened. Maryanne decided to enlist the help of friends. She called or emailed as many friends as she could and asked them to pray for us. In the meantime, everyone at the rehab centre, including all the staff, were also praying. I needed every one of these prayers because I needed a miracle.

When my initial shock subsided, I decided that my only hope was to offer Tex money for Skippy. I just had to believe that money would talk! So I went

and knocked on Tex's door. When he opened the door, I could see Skippy in the living room. When she saw me, she tried to push through Tex to get to me. He kicked her and she went flying back into the room. I watched this and thought I would scream, but knew that I had to do my best to hold myself together.

I calmly stated that I was willing to pay whatever he wanted. He told me no amount of money would make him change his mind. Skippy was staying with him.

I felt total despair. I was supposed to be on the plane in little more than a day. Should I accept that I would go home without Skippy? Everything inside me knew that was wrong—I had to try again.

One woman suggested I go over with the vet bill, show it to Tex and hope that when he saw the bill, he would be moved to give Skippy back. I jumped at this idea, ran over to Tex's house and showed him the bill. He didn't budge.

So many people were desperately trying to figure out a way to return Skippy to me, but each idea seemed to go nowhere. Even Maryanne was calling around the clock from Australia with suggestions, but again, none of them held out much hope.

Time was running out. I went back to my room and started packing. I was totally numb. I don't even know how I functioned. I had a fleeting thought that maybe I should call the airline and cancel Skippy's reservation, but I just could not do it.

I just had to see Skippy one more time. I walked straight over to Tex's house. I noticed that his truck was not in his driveway. As I approached his house, I thought I was hallucinating. Skippy was outside in the backyard! My heart was pounding. Maybe, just maybe . . . I ran to Skippy as fast as I could. She was running to me as fast as she could but there was a fence between us and the gate was barred.

I ran back to my house, got in my car and drove right back to Tex's. There was a huge barrel pushed up against the gate. When I pushed on the gate, nothing budged. I stepped back and then, with everything in me, I ran as hard as I could towards the gate and pushed with all my might. The miracle happened. The gate opened a few inches, just enough for Skippy to get through.

'Come on, Skippy,' I said to her, 'we have to get out of here!' I had left the car running and the doors were open. Skippy jumped into the back seat and I drove away as fast as I could. Tears were pouring down my face and they mingled with all the kisses that Skippy was giving me from the back seat.

I kept driving but was not sure where to go. I knew I could not bring Skippy back to the centre because Tex would find her. In a flash I knew what to do: take Skippy back to the vet's office.

It was about an hour's drive. Skippy continued to give me kisses and her tail never stopped wagging. I was laughing and crying the whole way. When I brought her in the door to Heidi's office, the entire staff ran to me, hugging Skippy and asking a million questions.

Heidi came out of her office and stared in disbelief.

I looked up at her and asked, 'Will you help me?' I did not have to wait for an answer. Heidi took over. She knew what time I was leaving the next morning and she grasped the situation at once. She arranged for Skippy to spend the night at her assistant's house and for me to pick her up at 4 a.m. on my way to the airport. On my way back to the centre, I finally started to relax but when I drove up the street, I saw lots of people in the front yard and a police car with lights flashing. Immediately I knew there was trouble.

I got out of the car. The policemen walked toward me. They asked me my name and then they asked me if I had Skippy. Out of the corner of my eye, I saw Tex standing in the crowd glaring at me. I answered, 'I don't have a dog.'

The police searched the house. Fortunately, Skippy's bowl, leash and toys had all been packed, so there was no sign that a dog had ever been there. They continued to ask questions and I just kept repeating, 'I don't have a dog.' Finally, I looked at them and said, 'How can I give you a dog when I don't have a dog?'

How the attorney for the rehab centre happened to arrive at just that moment, I will never know. He got out of his car, came up to me and asked me if I had Skippy. I kept repeating, 'I don't have a dog.' He asked me to talk to him in private, looked me in the eye and asked me, 'Do you have this dog?'

I had no idea whether I should tell him the truth or not. He could easily have turned me in. I decided to tell him that Skippy was at the vet's office. He listened to the story and walked back to the police. I had no idea what he was going to say to them. He uttered only one sentence: 'She obviously does not have the dog.'

Meanwhile, Tex remained furious and continued to accuse me of all sorts of things while the police went to the car for what seemed like an eternity. When they came back, they charged me with a misdemeanour. They told me quietly to make sure that if I ever came back to that state again, I should not get so much as a parking ticket or I could go to jail.

I could not even worry about 'being wanted' in the state of Florida. All I could feel was a glimmer of hope that Skippy and I would be together. I walked over to the main building to say goodbye and it seemed that absolutely everyone was there cheering. People were hugging me and giving me words of encouragement. My counsellor stood in the background and waited for her turn. She gave me the strongest hug and whispered in my ear, 'You and Skippy belong together. Now go home and take good care of her. This has truly been a miraculous healing for both of you.' We both had tears in our eyes.

The sun was shining, and as I looked up into the sky I said, 'Thank you, God, for this miracle.'

I could not sleep that night. I got up at 3 a.m., put my last few things in the car and drove to pick up Skippy. When I got there she was beside herself with excitement.

The sun came up as we drove along the highway together. I don't think I had ever felt such joy. I knew that this was a new beginning for Skippy and for me. We had met when we were both utterly desolate. Now we were both happy and at peace. And, best of all, we were together.

Dr Patricia Kentz

'Outside of a dog, a book is probably
man's best friend, and inside of a dog,
it's too dark to read.'

Groucho Marx

Rules from the Dog Universe

When loved ones come home, always run to greet them.

Never pass up the opportunity to go for a joy ride.

Allow the experience of fresh air and the wind in your face to be pure ecstasy.

Take naps.

Stretch before rising.

Run, romp and play daily.

Thrive on attention and let people touch you.

Avoid biting when a simple growl will do.

On warm days, stop to lie on your back on the grass.

On hot days, drink lots of water and lie under a shady tree.

When you're happy, dance around and wag your entire body.

Delight in the simple joy of a long walk.

Be loyal.

Never pretend to be something you're not.

If what you want lies buried, dig until you find it.

When someone is having a bad day, be silent, sit close by, and nuzzle them gently.

Enjoy every moment of every day!

Everything is always OK in the end; if it's not, then it's not the end.

Anonymous

The Little Red Man Says 'Don't Walk'

Our brief as puppy walkers for Guide Dog Services is to socialise the pups in as many different situations as possible so that when they leave us for specific training, they are comfortable in their surroundings. Guide dog puppy Roselle and I had many 'conversations' about what she was and was not allowed to do, regardless of how the general public behaved.

We exited the mall and headed for the pedestrian crossing. As we approached, the Little Green Man on the traffic lights disappeared. The Little Red Man started flashing: 'Don't Walk'.

We stopped obediently and waited, and I wondered how many fellow pedestrians I would label Crossing Crashers that day.

True to form, the first group, Teenage Boys on Skateboards, flashed onto the scene. Without a sideways glance, they scooted over the crossing and continued down the footpath on the other side.

My little companion looked up at me. 'They have this terrible fear that if their wheels stop, they will seize up permanently,' I told her.

Next came the Young Business Executives. Most paused momentarily, then stepped out between cars. 'They've all done road safety in Italy. Cars and pedestrians weave around each other there,' I felt obliged to explain.

A Young Mum with Pushchair clipped my ankle and proceeded onto the crossing. 'That one believes that if she pushes her child onto the crossing first, everyone will stop for her,' I said.

Still the Little Red Man said 'Don't Walk'.

Local Business People stepped around us. 'They've all paid their accident insurance, so they think if they are hit they may get some money back.'

A Retired Couple with shopping bags tentatively stepped out. I could feel the question coming. 'Why should they not wait here with us?'

'Two possible reasons,' I explained. 'The car park across the road has one hour of free parking, and the time is about to expire, or,' I whispered, 'they

74

are racing across to the toilets!' I don't think my little friend understood. Still we waited. Had the Little Green Man gone on holiday?

Out of the corner of my eye I saw it—the quick step onto the crossing, the hesitation of the highly polished shoe, which finally withdrew to stand beside us. Did he hear me mutter, 'Not you too!', or did he look down and see my little black friend in her smart red coat with the bold legend 'Guide Dog Puppy in Training'?

'I suppose if I cross that's a bad example, or confusing for her. I bet this happens all the time,' he said.

My Hero.

'You said it,' I sighed. 'The stories I could tell you.'

He was saved from my ramblings by the Little Green Man buzzing loudly and flashing importantly, 'Cross Now'.

But still we stood there, and I could feel the desperation and frustration as he wondered if he was doomed to remain standing with us forever. 'It's OK,' I explained. 'We're just making sure that there are no cars running the red lights.'

He sighed with relief and followed us across. 'Have a good life,' he called to Roselle.

'May you win Lotto soon,' I replied for us both.

Marilyn Valder

Now I Lay Me Down to Sleep . . .

Now I lay me down to sleep,
The king-size bed is soft and deep.
I sleep right in the centre groove
My human being can hardly move!
I've trapped her legs, she's tucked in tight,
And here is where I pass the night.
No one disturbs me or dares intrude
Till morning comes and 'I want food!'
I sneak up slowly to begin
my nibbles on my human's chin.
She wakes up quickly,

I have sharp teeth—
I'm a puppy, don't you see?
For the morning's here
and it's time to play
I always seem to get my way.
So thank you, Lord, for giving me
This human person that I see.
The one who hugs and holds me tight
And shares her bed with me at night!

Anonymous

'The dog was created specially for children. He is the god of frolic.'

Henry Ward Beecher

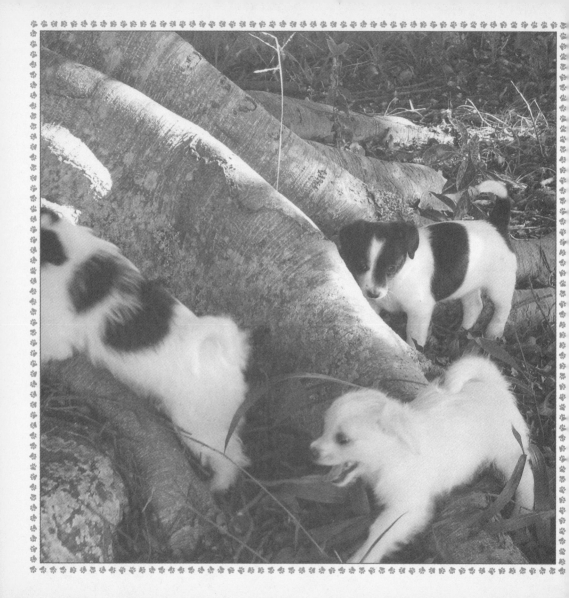

Charlie the Circus Dog

In my lifetime I must admit to knowing what at least one dog wanted. This was Charlie, better known as Puppy. What he wanted was to run away and join the circus.

Puppy was a sportsman, a gymnast, an athlete. He was a medium-sized, good-natured, amazingly agile black mongrel. He could run straight up and over a three-metre-high fence. He was conditioned to chase and catch, and did these things as reflexively as any Test cricket fieldsman. He always caught tennis balls on the first bounce. (He anticipated the angle of ricochet.) If you put a stick on top of a playground slippery-dip, he would climb the metal ladder, pick up the stick and slide down, grinning, with the stick in his mouth.

Puppy was never home. Because he was easily able to scale that three-metre back fence, he would do so. Every day. Mostly I'd find him down in the park, leading a merry band of similarly minded scoundrels. When I whistled, he

would stop what he was doing and tear towards me. Even when he was having fun, he loved to see me appear.

He was a ten-year-old's dream dog. Unfortunately I was thirty.

He loved me, he loved the family, but he was a genuine wanderer, at the mercy of his genews and glands. You'd glimpse him from the car 4 kilometres from home, performing tricks for strange children in front of a block of flats, or walking purposefully along the harbour wall. He and his lightning reflexes were also at the mercy of five cackling teenagers next door, who'd whistle him over the fence and incite him to ever greater risks by throwing balls into the traffic or into the harbour.

The more he went out and the worse company he kept, the harder he was to control at home (once he'd apologetically eaten and drunk and slept for twenty-four hours, that is). When a tough old spayed bitch taught him to chase cars, he was hooked, and our last vestige of discipline disappeared.

And so I found myself in the haunting, never-anticipated position of having to send a dog to the country.

This, however, unlike my parents' decision to send my childhood friend Shep 'to the country', was the genuine country, a farmlet west of Sydney, on whose 50 acres Puppy's skills and energy would be better tested than in a

four-metre-wide terrace house. Of course sending him there was kinder than keeping him. The way his life was going, the way he was burning the candle at both ends, this decision would almost certainly prolong it.

Thus I convinced myself. In those days, at a time when I had other, pressing, human things on my mind, it was a shockingly easy decision to make. Strange, then, that the old belief has lately resurfaced. That to be 'sent to the country' really meant to be sentenced to death.

I find it difficult to talk about Puppy. I feel a strong guilt about him. What did I think I was doing?

Robert Drewe

Being Owned by a Dachshund

I have had the pleasure to be surrounded by eight Dachshunds throughout my lifetime. Four are still with us—three of them own my husband and I, and the fourth one, Susie, owns my father. The reality is that my husband and I work to pay our Dachshunds' mortgage.

My love of Dachshunds started soon after I was born. My parents had a standard red short-haired female named Penny, along with a Whippet called Minnie. Penny's life was cut short due to facial cancer and she died when she was thirteen.

In 1988 I took under my wing an eighteen-month-old pure-bred standard tan called Honey. Her owner was elderly and had to go into a nursing home. Honey lived with us until the ripe old age of sixteen, when her legs failed her.

While we still had Honey, we rescued a long-haired tan female called Maggie. Her so-called loving owners didn't give her the attention she deserved.

She was fed only canned food, was kept as a yard dog and not allowed inside. When we picked her up she had hardly any teeth from eating only canned food, and was a bit tubby and of course very timid. Her owners had advertised in the paper to give her away because they said they were moving overseas.

I still think it was a lie. I just think they couldn't be bothered caring for Maggie, even though she was a lovely dog. Poor Maggie only survived another twelve months. She dropped dead of a heart attack, which devastated my family. But I felt honoured that at least we had been able to love and care for her for the last year of her life, even if we couldn't do much about the way she was treated by her previous owners.

When I bought a home with my fiancé (now husband), I had to get a Dachshund and that's where Sandy steps into the story. In June 1998 we took ownership of her—or rather, Sandy took ownership of my husband.

Sandy is a standard black-and-tan short-haired Dachshund who is also known as Houdini due to the fact that twelve years on Sandy is still going strong. We think she has used up most of her nine lives!

A malignant tumour tried to take her but failed, then she had a fight with the rose garden—and yes, the roses won, leaving Sandy looking like a nanny goat with a bandaged ear. These days, apart from the normal lumps and bumps

of old age, she is still as active as she was when she got us. She loves her walks and loves to get out and explore. Sandy is very loyal to me and I know it will be a sad day when she does pass away. She has been with me from the beginning of our lives—in our first and now our second home, and she even attended our wedding as well.

We felt sorry for Sandy being home alone while we were at work, so we started searching for a little friend for her. (All of our Dachshunds have always been desexed because as much as we would have loved to breed Dachshunds we didn't—and don't—have the time or money.) We took Sandy along to a Dachshund breeder so that she could choose a puppy for herself. We were a bit worried she would not accept another dog into her life, but we were as wrong as could be.

As soon as we got there, Sandy's maternal instinct kicked in. She loved all the puppies and wanted the lot, the look on her face saying: 'Look, Mum, look at all these puppies!' I told her she was allowed only one and asked her which one it was to be, but she couldn't choose. She just licked and played with them all.

In the end we all decided on a caramel-and-white male and we brought him home with us. To reduce any risk of Sandy getting bossy, the local dog

shelter advised us to walk them both through the front door at the same time, and it worked—there was no dominance from Sandy. She protected her new puppy, whom we'd called Charlie Brown, from the first moment.

I told Sandy that since it was her puppy she was now responsible for him and she took to this role at once, always keeping a motherly eye out for Charlie Brown. They became great mates and were good company for each other.

Fast forward a few years to when my husband was working at a house in Sydney's inner west and the family he was doing work for had a miniature male Dachshund called Woody. The children had named him Woody after the movie *Toy Story*. The father worked for the Australian Navy, so the family had to keep moving around and had decided that it wasn't fair on Woody. Having seen how my husband doted on Woody, and after he had mentioned how we were owned by two Dachsunds, they asked my husband if we would like Woody too. When my husband phoned me to tell me we had been offered a one-year-old Dachsund for free, I thought he was joking. But a week later Woody joined our family and we were now owned by three Dachshunds.

Less than a year later, we left the city for a more rural lifestyle. Our three hounds loved hanging out in the countryside. Life was perfect for a few years until we tragically lost Charlie Brown. A brown snake took his life in our own

backyard. My father said Charlie deserved a medal for protecting us and his home from the snake.

Everyone who knew Charlie Brown cried at the news of his death. His former veterinary surgery in Sydney even sent a sympathy card, they so loved him. He was such a sweet, affectionate dog—to know him was to love him.

Of all the Dachshunds I have had the pleasure of being owned by in my life, Charlie Brown was the most adorable, intelligent, cheeky and downright human. He could sit with my husband and me and get seriously involved in our conversation. He seemed to know exactly what we were talking about. Charlie Brown appeared on television and he and Sandy also won a dog photo competition. Charlie was so special he had the pleasure of staying in motels— and how many dogs can say they've been invited to join their human parents on a museum tour because they are so well behaved!

After Charlie Brown passed away, his stepbrother Woody started to fret. I didn't want to see a replay of the time when Penny, my first Dachshund, died. Her best friend Minnie the Whippet fretted for her so badly that she got pneumonia and died within two weeks—of a broken heart, I've always said. I didn't want to lose Woody the same way so, in order to stop him mourning for Charlie Brown, we got in touch with a very compassionate

Dachshund breeder and not long after Ruby Rose, a recessive long-haired standard, came into our lives. Incredibly, she has almost all the same characteristics of Charlie Brown. We really feel Charlie Brown arranged for us to meet up with Ruby Rose.

These days, our Dachshund family consists of Sandy, who is now twelve, Woody, our five-year-old miniature and Ruby Rose, aged three.

It breaks my heart to see people who buy a dog and don't take an interest in its life or health. If you want the privilege of being owned by a loyal dog, then take it for walks, feed it well and please adhere to your vet's advice—desex, immunise and of course microchip.

A dog can live for fifteen years or more, so think seriously before you decide to bring one into your family.

Carol Tomek

'I have a great dog. She's half Lab, half Pit Bull. A good combination. Sure, she might bite off my leg, but she'll bring it back to me.'

Jimi Celeste

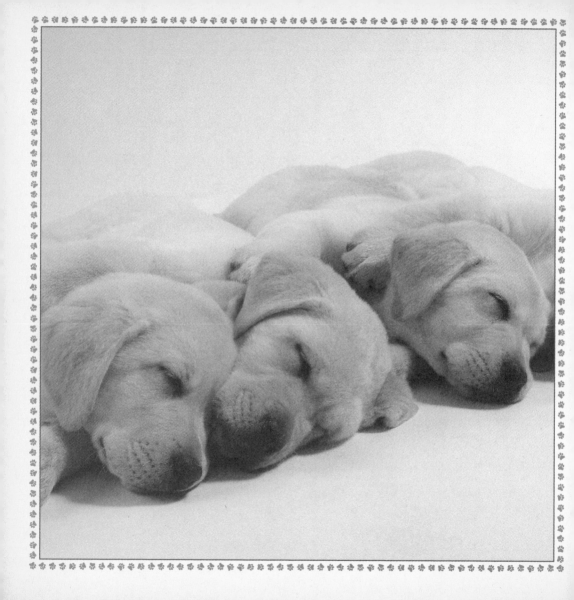

A Dog Owner's Day Off

This email was sent from a guide dog breeding stock guardian to her husband at work. Georgia and Wickham are Golden Retrievers.

It all started when I tried to comb the dogs before going for a walk. Georgia got excited, revved Wickham up, and off they both went, chasing each other around the lawn.

I gave up and decided to go to the library. But even though I watched them when I opened the gate, they were so hyped up that quick as a flash they were off down the drive.

Wickham chased the sheep that were grazing on the drive, but Georgia just mucked about. Wickham came back when I called but by then Georgia's memory had kicked in and she went under the paddock gate into the water trough.

My heart sank. I knew exactly where she was headed.

She followed her old trail and two troughs later finally found the pond. Her luck was in. A duck was lazing about, minding its own business. That was soon to change! It was 10 a.m. At 12.40 p.m. I got her out!

For future reference, should you ever be in this position, here are some tips:

1. Waiting patiently at the side of the pond hoping she will come out does not work.
2. Finding a big net on the end of a pole and hoping to catch her does not work. (It only works with fish.)
3. Giving up and going to deadhead your roses while you wait, hoping she will miss you and find her own way back, does not work.
4. Speaking in a nice happy voice (very hard in the circumstances) and throwing food to entice her closer does not work.
5. Doing your gym workout does not work.
6. Putting the dinghy back in the water and tying it to a post because you have no oars, hoping to drift out into the middle and grab her, does not work.
7. Finding one oar and pushing yourself out does not work. The duck kept away, and so did she.

8. Rescuing Wickham from his kennel, where he has been since chasing the sheep, putting him on a long five-metre-line and allowing him into the pond so Georgia will get entangled in the line and you can pull her out DOES WORK!

I hose her down and put her in the old dog run in the sheep yard. Yes, the one with all the grass growing through it. She probably falls fast asleep after chasing a duck for two hours and forty minutes. Why didn't the duck just fly away instead of diving and coming up on the other side?

As for me, I have a shower, throw my clothes in the wash and am about to have lunch, after which I will carry on to the library—three and a half hours later. (Keep in mind that I am freshly showered, moisturised, perfumed and hair-washed!)

I am halfway through lunch when I hear a dog barking. Sounds familiar but distant, but I think perhaps I'd better go and investigate.

No sign of Wickham, and the barking is coming from the pond. No, dear husband, I did not leave the gates open. I follow the noise and find Wickham in the pond with TWO SHEEP!!!

There is no nice talking this time! He is too scared to get out as I am soooooooooooooooo mad, but he does. After taking him back, I change into my overalls and gumboots and pick up the long pole with the net on the end. I have to get in the pond to get to the sheep—mud to my knees. I put the net around the head and use it to get them out. The net can no longer be used and my gumboot is stuck in the mud somewhere under water, but the sheep are out.

I have just had another shower, but I think I still have mud in my hair. I have had a huge chocolate fix—it is too early for wine. I am now going to the library and I just might not be back!

Janet Thrush

'A dog is not "almost human" and I know
of no greater insult to the canine race
than to describe it as such.'

John Holmes

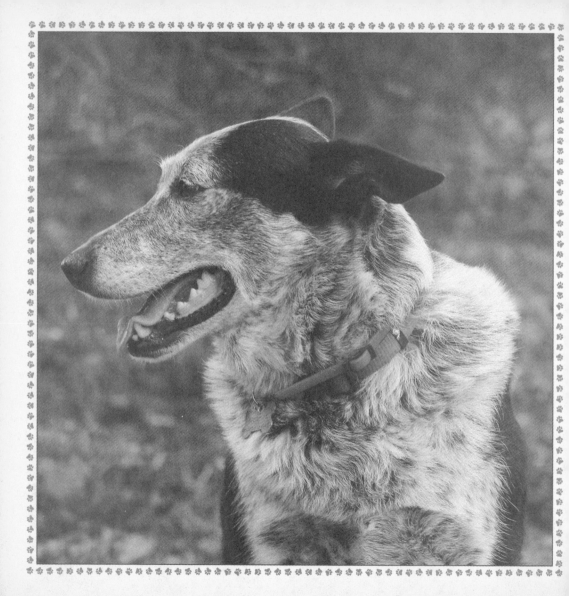

Epitaph to a Dog

Near this Spot

Are deposited the Remains of one

who possessed Beauty Without Vanity,

Strength without Insolence,

Courage without Ferosity,

And all the virtues of Man without his Vices.

This praise, which would be unmeaning Flattery

If inscribed over human Ashes,

Is but a just tribute to the Memory of

BOATSWAIN, a DOG,

Who was born in *Newfoundland* May 1803

And died at Newstead Novr 18th 1808.

George Gordon, Lord Byron

And Then There Were Four

Years ago when I was a teenager I had the pleasure of meeting some amazing dogs—and their owners weren't too bad either.

I came from England to Australia thirty years ago and worked in a café/restaurant in a small country town. There I met Danny, the blind dancing Collie dog; Cassowary, a beautiful, regal Alsatian; and Leo, a large German Shepherd–Dingo cross who looked like a Lion.

These three dogs and I would walk in the bush for hours on end. Danny would put his nose against my leg and off we would go.

He got his name 'dancing dog' because when he sensed or smelled a friend was near he would do this fantastic dance. Each afternoon when the school bus arrived, Danny would bump down the road, using the edges of the cars to guide him, so he could do his dance for his favourite people—the two sons of the family for whom I was working.

Leo, it was said, used to let Danny hold his tail when they were young dogs and lived in Sydney so they could go for walks together around the city streets. In the country, Leo loved to go into the river to cool himself off. There was a veritable smile on his face, and sometimes I saw steam rising all around him as this long-haired layabout sought relief from the summer sun.

Cassowary was naturally aloof but when that dog loved you, she was a friend for life. She was so intelligent she put some people I knew to shame.

She did not like it at all when the eldest son and I started dating. She used to sit and watch us like a hawk, and if we got too close she would jump between us and look deep into his eyes. We were never sure if she was saying: 'Keep off her, she is my friend,' or 'I am your favourite, not her.' Either way, she did not like it when we started locking her downstairs.

One day, Leo and Cassowary got away by themselves, and sometime later there was a litter of puppies, of which we kept one—Gandalf, a very large, jumpy pup. So now I had four extremely large dogs to walk and play with, and I just loved being surrounded by them all.

After a time, I moved to the city and did not go visit my friends for a year, but when I did go they'd wrapped the restaurant in butcher's paper and written 'Welcome home' all over it. Confusingly, there was no one around

and no sounds could be heard. Then suddenly there was a noise like thunder—just like thunder—and I was knocked off my feet by three Alsatians and one blind Collie. They had been locked upstairs, but Cassowary had worked out how to turn the handle and got them out of the room. This spoilt the human surprise somewhat and everyone came laughing out of the kitchen where they had been waiting for me.

The four dogs did not leave my side for hours, and Danny danced so much I thought he was going to fall over. I have never forgotten their love. It was yet another lesson about animals—they really do have memories. Dogs are so often man's best friend, and in their minds they continue those friendships even when we are not there, as we do with them.

Charlotte Brooks

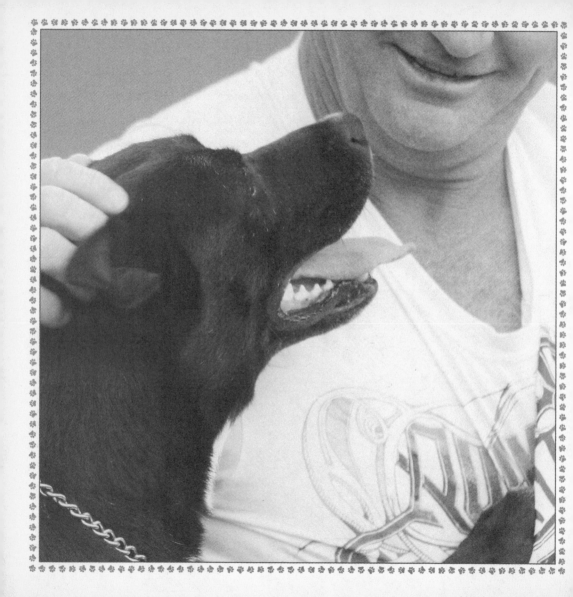

Gelert the Great

In the Glaslyn Valley, high in the mountains of Snowdonia in north Wales, is the little picturesque village of Beddgelert. Among its attractions is the grave of a famous dog, Gelert. This was how the village got its name: Beddgelert, meaning Grave of Gelert.

As much as this is the story of Gelert, it is also the story of one of Wales's great princes, Llywelyn the Great. He was born in the year 1173 in the beautiful Lledr valley, on the eastern side of Snowdonia. His home stood on a knoll on the southern slopes of Moel Siabod, guarding the way west over Snowdonia from the Conway valley. It was prone to the fortunes of the weather and, with its rising mists and cold, bitter winds, the castle was an unforgiving place. It was also a cold place in the time of snow, but snow helped to seal the valley against those that on many an occasion wished they could break the stranglehold of Snowdonia by the Prince of Wales.

Llywelyn enjoyed hunting, for it not only gave him the thrill of the chase but provided meat for the table. Whenever he could, he would leave his court of Aberffraw, cross the Mennia Straits and head for the mountains of Snowdonia with his great Irish Wolfhound pack. Its leader, Gelert, could be heard baying as they picked up the scent of a stag and began the chase. Many times they would lose a scent, then pick up another, only to lose that one too. By then Llywelyn would find himself way to the south, and indeed there were occasions when he was as far south as the Mawddach river, causing him to camp in his newly built castle of Bere in the Desenni valley, which meant he was away from his wife, Joan, for weeks at a time.

After Gruffudd, the Prince's son, was born, Joan did not want her husband away for so long and demanded that he should build hunting lodges so that she and the baby could accompany him. It is the one that was built near today's Beddgelert that concerns us, for this is from where my story of Gelert the Irish Wolfhound comes.

The great bounding Wolfhound was a favourite of all who met him. He was as gentle as a lamb to those that showed kindness to his master and his family. But woe betide anyone who the dog thought was rude or disrespectful.

He would sit right in front of the visitor, bare his teeth and emit a deep warning growl.

At meal times Gelert would sit at his master's side, the only one of the pack allowed to do so. His head would loll to one side and his tongue would hang out, while one ear would be cocked for the sound of the slightest movement of a tasty titbit from the table.

When Gruffudd was old enough to crawl, the youngster was as rough as he could be with Gelert; in fact the great dog was often seen walking around the lodge with young Gruffudd hanging onto his tail. When the little prince was put to bed, Gelert would lie alongside the cot to protect his young charge.

So devoted did the dog become to Gruffudd that he grew reluctant to go out on the hunt. Llywelyn naturally wanted his pack leader with him and would shout at him or try and cajole him in an attempt to get Gelert to accompany him. Gelert, however, would have none of it; he would bare his teeth and growl at Llywelyn too. Soon the pack had a new leader and the giant hound stayed at home protecting his charge. When Gruffudd became a toddler he and Gelert were inseparable.

Late one autumn, when Llywelyn and his family were at Beddgelert, the great dog died. Young Gruffudd had been put to bed and his father and the

hunting party were away up the valley, where the hounds had trapped two great stags. On returning to the lodge after the successful hunt Llywelyn, who was eager to see his son, burst in through Gruffudd's bedroom door, there to be met with a devastating sight. The cot was overturned, there was blood everywhere, and worst of all the great Wolfhound's jaws were dripping with blood. Thinking that Gelert had turned on Gruffudd and savaged him to death, Llywelyn withdrew his sword and plunged it into Gelert's side. The howl of the great dog as it sank to the floor in its dying throes reverberated through the mountains all around.

Beside himself with rage, Llywelyn almost missed the little snuffling noise coming from the corner of the room. When he noticed it, he rushed forward and threw aside the empty cot, and there below it was Gruffudd, still alive. Even more surprising was that underneath Gruffudd was the body of the biggest wolf Llywelyn had ever seen. Understanding in a moment what had happened, Llywelyn was filled with remorse and rushed back to the great Wolfhound's side. Cradling the dog's head in his arms in an attempt to ease its pain, Llywelyn received one last lick from the great dog, as though in forgiveness, before he died.

Months after the death of Gelert, Llywelyn, still beside himself with grief and contrition, erected a memorial stone south of the village near the Glaslyn river, where he had laid the great dog to rest. Many hundreds of years later the stone is still there today, cared for with love by the residents of Beddgelert.

Candida Baker

My Pet

He may not be a show dog,

He's never won a prize,

But I'd pass up blue ribbons

For the love in those brown eyes.

The famous dogs of Ireland

In days of long ago

Like brave Gelert, who saved a child,

Had never seen a show,

But what they had of value

Was the heart that beats within

Each true descendant of those sires,

That thing beneath the skin

That stamps an Irish Wolfhound

Be he champion or pet,

The heritage, that down the years,

These dogs do not forget.

It doesn't really matter

If he never scores a win,

For the thing that makes a Wolfhound

Is what lies beneath the skin.

'He is your friend, your partner, your defender, your dog. You are his life, his love, his leader. He will be yours, faithful and true, to the last beat of his heart.'

Anonymous

'Dogs' lives are too short. Their only
fault, really.'

Agnes Sligh Turnbull

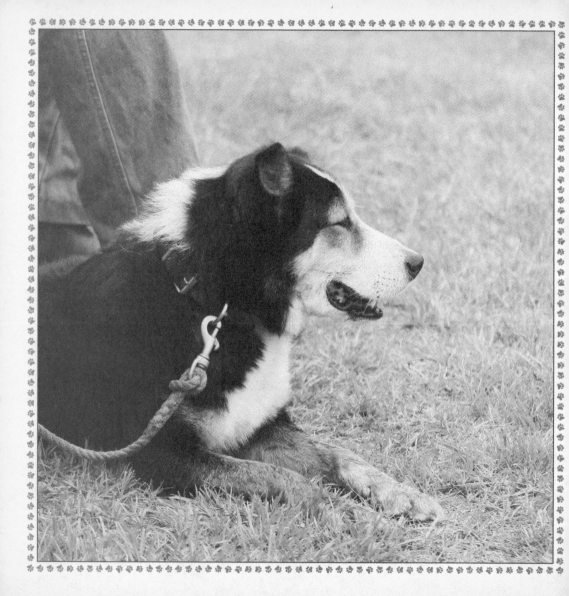

Renewal, Not Replacement

One thing about travelling everywhere with a guide dog is that people often talk to you about their dogs. I have lost count of the number of people who have said to me, 'I had a dog but he died, and I'll never have another. I couldn't go through that again.' I sympathise, oh how I sympathise, but such declarations always make me ineffably sad.

There is no getting away from it: losing those we love, with or without paws, is the worst kind of trauma most of us will ever face. Expecting it doesn't help; knowing it is inescapable or even imminent rarely makes any difference. The pain is as excruciating as it is inevitable.

Most relationships involve some degree of interdependence. We all need to be needed, and most of us want to be loved, even if we don't admit it. Our dogs need us for food and shelter, somewhere to sleep, and what I consider essential extras: love, companionship and play. Not much to ask when you

consider that in return they give us unconditional love and complete devotion. They see us in the extremes of sorrow and joy, hope and despair, anger and boredom; they know everything about us, yet still they love us. Your dog will not judge you for taking that one glass of wine too many or saying something unpardonable to your in-laws, and will keep all your secrets. I would trust my girls to keep their counsel even if they were cross-examined by Dr Doolittle. It is not surprising, then, that when my last guide dog died I was devastated. Dori had held my life in her paws for almost ten years and was my shadow whether I deserved her care or not. Her final hours were extremely painful, causing a sadness that lives with me still. At nine o'clock on Saturday evening she was dancing round the kitchen in my arms, hugging me as she always did after her meal; by four-thirty on Sunday morning she was gone. A twisted bowel is a swift and merciless assailant; she fought valiantly but the struggle was unequal. Simply writing about the anguish is to relive it. I felt sure the scars on my soul must be etched across my face for all the world to see. Both kind words and careless comments reduced me to tears within seconds; my confidence was shattered, hope vanished, time stood still.

People were wonderful. My home and office were filled with flowers for weeks and tributes to Dori flowed in from across the globe, including one

from Nicholas Evans, the author of *The Horse Whisperer*, whose life Dori enriched for a few moments when we'd met in a radio station corridor. Nicholas was with my friend Maggie, who'd hugged me when she saw me, and Dori immediately decided she should bestow the same honour on the other human in the equation in case he should feel left out.

I tried to cherish such memories even while mourning her. Dori had come to us almost a split personality, two dogs in one skin. On the one hand she was a dependable, responsible worker who would treat a sandwich on the pavement as an obstacle for me and ignore a child bouncing a ball across the street, on the other she was a confused, insecure soul desperate for attention. Watching her grow into a confident, protective companion was a joy beyond price.

There is a theory that the only way to honour a former guide dog is to train with another one. There is no reason why this should not apply to all dogs. Only you can decide when or if you are ready to share your life with a new dog. I can only tell you how much joy repeatedly taking that risk has brought to us over the years. Every time any one of us makes a new friend with any living being we take that same risk, yet without the love of others, with or without fur, the world would be a sad and lonely place. You can read elsewhere in these pages how two dogs saved me from myself after Dori died.

German Shepherd Allie became my shield, and Rosi's need for love equalled my need for hers; as far as she was concerned having me fall in love with her was not negotiable.

You will notice that I referred to sharing your life with a new dog rather than a replacement. No person or animal can truly replace another. If it were otherwise, we would all be mere clones. Therein lies the key to making each new relationship work. Comparing the new recruit with the old beloved dog is not a good idea; in fact, it is downright destructive and I had to stop myself doing it when Rosi first arrived.

Teaching dogs good manners and basic obedience is not incompatible with allowing their individuality to shine through. There are often hiccups in the early stages of a new relationship as you both learn to interpret and understand one another. Once you're on the same wavelength and the bond is established you will be surprised how quickly love and understanding can flourish. Yes, personality clashes do happen, but they are less likely to become insuperable if we invest time and effort where it is needed. Our relationships with our dogs require work but pay priceless dividends. Rosi's daily leaping on to the bed to say goodnight, or burrowing into my husband's arms when she was frightened by a thunderstorm; Allie's attempts to protect me from the menace

of the growling hairdryer and her habit of rubbing round my knees in greeting like an enormous kitten; their mad rush to be first to reach the car or their operatics when we arrive at the beach—the list is endless, but these gestures all enrich our lives every day.

If you lose a dog, you should at least consider adopting another one. I cannot promise you there will be no pain—no one can do that—but I can almost certainly guarantee what managers call a 'win-win situation'. Love's capacity for growth is infinite, and as Donny Osmond told us years ago, puppy love has long been vastly underrated.

Elaine Harris

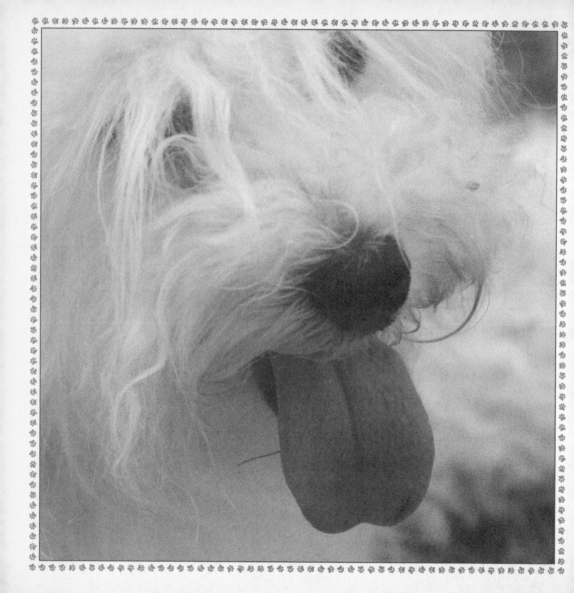

Bree's House

I handed Dad the screwdriver. He was having a hard time with the simplest of jobs these days, but he would never admit it. He was a smart, loving man but he was also a proud man. People said I took after him and I presumed they weren't talking about looks.

'No, not that one. The Phillips head.'

I reached into the tool box and grabbed the other screwdriver. He was fastening a plaque to the front of the house.

'Do you miss her, Dad?' I asked.

'Of course, love, don't you?'

'Every day.'

We had lived in this house my whole life, and out here, on the front verandah, was one of my favourite spots. Over the years, the verandah had changed the least. It reminded me of the beginning, of the stories I had been

told about my mother from the time before I was alive and when she was still with us.

Mum passed away when I was two. It was a tough time for Dad. The house they had bought together was halfway through major renovations, and he was faced with paying a mortgage, bringing up a daughter, finishing the renovations and maintaining a day job—all on his own. He did it, to his credit and to his family's utter surprise, and he always remained relatively pleasant and positive.

But as I got older, I noticed he would go on long walks, and I started to follow him. He went to the park down the road and would sit alone, at a picnic table, and just stare. It was a dark and heavy look that seemed to take him far away. I imagined he was thinking of her, picturing her, willing her back into our lives.

After an hour or so he always came home cheery and with the light back in his eyes. But he was always alone, and I could see that it hurt him. Except one day, around the time of my ninth birthday.

'Daddy, it's a doggy!' I squealed as he walked through the front door with a tan-coloured, mangy, skinny little dog trotting proudly behind him. She was like nothing I had ever seen before. She had gigantic ears that stood up like

satellite dishes on the crown of her head and her forehead was so wrinkled that she looked worried, even when her curly pig's tail was wagging like crazy. I thought she was the most beautiful creature I had ever seen, besides my inner fantasy pictures of my mum.

'Yes, darling, she's a dog.'

'Is she ours?'

'Well, no . . .'

'But can we keep her?'

'Let's just see what happens, shall we?'

'What's her name?'

'Um, I don't know.'

'Why is she here, then?'

'She followed me home from Bendooli Park.'

'Maybe that's her home.'

'No, honey, I think she's a stray.'

'Maybe that's her name?'

'What, stray?'

'No, Dad. Bendooli!'

'Are you a Bendooli?' Dad asked the dog. 'Beni?'

And with that, this odd-looking creature launched itself into my father's arms.

'Beni it is!' he said laughing, just as the dog nuzzled into his face and licked him right on his open mouth.

The next morning, Dad and I took Beni to the vet.

'She definitely appears to be a stray. She's extremely undernourished and has quite a few fleas,' the vet said, looking into Beni's big chocolate-brown eyes. 'And as for the breed, she's certainly an unusual one. I'd say she's a cross between a Foxy and maybe even a Basenji.'

'Benji?' Dad asked.

'Ba-senji,' repeated the vet. 'They're a rare African hunting dog. Extremely smart but extremely stubborn dogs. It would explain the big, upright ears and the curled tail. You'll be happy to know that Basenjis can't bark, so although she'll protect you fiercely, she won't keep you up all night. It looks as though she's about two or even three years old, but it doesn't look like she's been desexed, so she may even have had puppies. You'll have to monitor her cycle and then book her in straight away for the operation.'

'Her what?' Dad said.

'Her cycle. Her menstrual cycle. Do any of your neighbours have dogs?'

'Yes,' Dad said, 'most of them.'

'Well, this can be a little awkward but I'd suggest before you leave her alone at home you cut the sides off an old pair of underpants and tie them onto the dog. This will prevent her falling pregnant just in case she comes on heat and any of the neighbours' dogs jump the fence.'

The look on my dad's face was priceless.

'We can do that!' I said. 'Beni can have my old knickers.'

Dad didn't look convinced.

'It's only temporary,' the vet chimed in, 'until we know more about your dog.'

We had a wonderful weekend, one of the happiest of my life. Beni was a beautiful companion for Dad and for me and, as the vet predicted, she was one smart dog. We spent most of the time in the backyard, teaching her tricks. She was extremely agile and quickly learned how to climb up to my treehouse and how to jump up into Dad's arms and onto his shoulders. She also loved the sensation of swinging off the clothes line, holding on by her teeth to a pair of Dad's socks. He didn't like that trick so much.

So when Monday rolled around and it was time for me to go back to school and for Dad to go off to work, the underpants came out. Dad held Beni while I tied on the makeshift chastity belt. We stood back to admire our handiwork and we both burst into laughter. It wasn't every day you saw

a dog wearing floral undies! The poor creature looked at us with embarrassed eyes that said, 'What did I do to deserve such harsh punishment?'

All day at school I thought of poor Beni wearing my undies, and hoped she was OK and that I hadn't tied them too tight. But when Dad and I got home and I raced to the back door, my worry disappeared. Beni was hanging off one end of the clothes line, swinging around, as Jacko the three-legged Jack Russell from next door acted as her counterweight by swinging from the opposite end. The undies lay torn to shreds on the grass.

Poor Beni. Her one afternoon of bliss with Jacko came back to haunt her because a few weeks later we had a litter of scrawny puppies. Beni's labour caused her excruciating pain and she spent over seven hours in the kitchen under our breakfast bench, giving birth to six little sacks of skin. Afterwards, Dad gave her a full tub of vanilla ice cream, and she lay there licking until the tub was bare.

The puppies grew quickly and, despite my pleading, Dad placed an ad in the local newspaper to give them away. It seemed that every day strangers came to our house and left with a puppy, which so distressed Beni that she just sat in the treehouse and watched silently.

The five most sprightly puppies were taken, but no one wanted the youngest and smallest of the litter, Beni's runt. After two weeks of no interest, Dad

finally agreed to let me keep her. We named her Bree, after the street Bendooli Park was on.

Beni and Bree didn't have a typical mother–daughter relationship. It was more a love–hate relationship. I think Beni had given so much love to me, Dad and her other puppies that she simply ran out. The traumatic birth had also taken a lot out of Beni and she just wasn't as lively any more.

When Bree was about a year old, we came home to find her but no Beni. We could only presume Beni had jumped the fence as only she could and returned to her straying ways. She was a headstrong thing and if she didn't want to wear undies, she tore them off. If she didn't want to be fenced in, she jumped the fence. Dad blamed himself and started returning to Bendooli Park, but she was never there.

Bree, however, loved all the attention she now received after her mother left. Bree was a gentle, sweet dog and would let me dress her up at Christmas. She followed me all around the neighbourhood, and she slept outside my door every night.

She wasn't as smart or agile as Beni, but what she lacked in skills she made up for in pure love and devotion. She became my best friend and was my

confidante during those early years of high school, when everyone seems against you. What I loved most about Bree, though, was that she was my dog.

Bree was with us for over twelve good years but, like all the amazing females in Dad's and my life, eventually she left us too.

'Don't cry, honey,' Dad said. 'You've still got your old man.'

Dad fastened the final screw to the wall and grabbed my hand. We stepped off the verandah to admire the shiny plaque now adorning the front of the house. It was inscribed with one word: Bree.

We never forgot Beni, but Bree was born in our house, she had died in our house, she had been buried in our backyard, and now the house would forever be hers.

'It's you and me, kiddo. Always has been, always will be,' Dad said. 'Job well done. Come on, let's go inside.'

Simone Smith

'I wonder if other dogs think poodles are members of a weird religious cult.'

Rita Rudner

The First Dog

If you are lucky enough to be born into a dog-loving home then inevitably there is going to be a First Dog. Many years later, when you are an adult, you will inevitably play the game where you put your first dog's name and the street name of your first home together in order to get your raunchier alter-ego.

My alternative name would be Minnie Belgrave; Minnie after our first family dog, a black Poodle who was a delightful companion for my early years, and Belgrave after the street in London where we had our first home.

I don't think it ever occurred to me that Minnie really belonged to my parents—after all they walked, fed and looked after her. As far as I was concerned she was mine, and that was that.

A curly small black Poodle was a perfect playmate for the early years of my life which were spent in relative affluence in a lovely part of London, with

nannies and au-pairs and walks in the park and a weekend country cottage. Minnie was pretty much the perfect family dog. She would sit, and fetch and play endless cuddling games. She was a happy and contented dog, with plenty of fun and games in her life, and she was always there if I needed a cuddle or had to explain to her that life was really very unfair for some reason or another.

When, for various reasons, my parents' finances fell apart and we moved to the rented weekend cottage in the country, which was fine by me. There were thousands of acres to explore, several ready-made friends my age, a life-long love affair with horses to begin, and a way to distance myself from a home-life already fraying at the edges.

Minnie, a puppy when I was a baby, was eight when we moved, and she too thrived in the country. She quickly made friends with other families in the village, and would wander up the lane to visit her favourites, Bill and Michael. She was particularly fond of visiting at the end of Sunday lunch when they offered a very high-standard cheese plate with titbits for Minnie.

Not unnaturally, after a few years of such treats Minnie's girth increased somewhat and as the years went by she became considerably less sprightly; although again I think she was probably the happiest dog I've ever known.

She had the occasional phantom pregnancy, and now and then a cyst that had to be drained. The cysts became more frequent as she got older, and I wonder now if perhaps with the phantom pregnancies she was actually suffering an hormonal imbalance that these days might be easy to correct.

When Minnie was about eleven, my mother noticed that she was bumping into things a fair bit, and also that her hearing wasn't quite what it had been.

A visit to the vet confirmed the fact that Minnie was, in fact, going deaf and also becoming gradually blind. It's a sad thing for a child, the realisation that your childhood friend is getting older so much more quickly than you, even though the years you have been on the planet are the same. But Minnie adjusted to her strangely twilit life with seemingly good humour. She got to know her surroundings so well she could navigate almost as if she could see, and was thrown off course only when a piece of furniture was moved to a new position.

One Sunday she wandered up the lane to visit the cheese-plate house, just as Bill and Michael were returning from their lunch-time drinks at the local pub. Somehow they managed to miss the fact that Minnie was in the middle of the road, and drove their Morris Minor straight over the top of her. Fortunately for Minnie her deafness and blindness saved her; she just kept

walking straight on, and the car passed over the other side of her with absolutely no damage done.

I never did remember to ask my mother if it was around this time that she began to think Minnie's quality of life was being seriously compromised, and that the combination of no sight, no hearing and the cysts was too much for her.

At some point, my mother must have made the decision that Minnie should be put down, and she must have relayed this information to me; although I don't recall her telling me, I remember I knew when it was Minnie's last day.

We took her to the river with us when we went for a swim, and I'll never know if she was telling us she was happy she was going to be going to doggy heaven the next day or whether she was trying to put in a protest, because she was as happy as a puppy all that afternoon. She raced and chased in circles balls she couldn't see and tumbled over herself and us, licking us and wagging her tail like crazy.

Needless to say I pleaded with a twelve-year-old's fervour that Minnie should be allowed extra time on earth, but Mum was firm. It was just a once off, she said. It was kinder to let Minnie go, and our afternoon by the river had given her a beautiful send-off.

Now, at the age of fifty-five, the strange thing is that I can't find a memory of what it was like to come home the next day to a house without Minnie—the first in my conscious lifetime. I don't remember if we buried her or if the vet took care of her body. I don't recall talking about her, although I am sure I did.

As a mother, I know now how hard it is to take that final journey with a family pet, but I don't remember my mother's sadness. Maybe she wasn't sad, maybe she truly felt that Minnie had been released.

But the memories of Minnie the little black Poodle have stayed with me my whole life. I have memories now of many dogs, all of whom have given me unconditional love, but Minnie holds a very special place in my heart, because she was and will always be the *first* dog.

Candida Baker

B----r Bogey

Bogey is a handsome Irish Setter who was born into a large extended family, made up of his mum, two sisters, various uncles, aunts and cousins and an occasional visiting ring-in.

The dogs all have acres of room to run about in, as well as most of the house because we have always wanted our four-footed friends to be part of the family. One of the ways we could identify Bogey from his many relatives is a raised line of hair running along the length of his nose.

His real name is Gaileas Blithe Spirit and it is a name that suits him admirably, because he is full of fun and mischief. Very early on we discovered that he has a sense of humour and a keen eye for the advantage to be found in any situation. For instance, if the phone rings and you have to get up out of your chair, he pinches the pillow behind your back and makes off with it

down the corridor to his bed. There he will place the pillow and rest his head on it, the picture of innocence.

During the day and in the evening, all the dogs are taken for a walk round our 3 acres of fenced-off land and it is not unusual to see Bogey joining in the procession carrying the pillow, his head held high with pride.

Bogey is a show dog in the real sense of the word and it did not take too long for him to be awarded Australian champion. Once he had letters to his name he was listed as 'Aust Ch Gaileas Blithe Spirit' in the show catalogue. He loves showing and he looks beautiful as he floats around the ring, his coat shining in the sunlight and his 'feathers' blowing in the wind.

As he's grown in stature and maturity, he has still never lost that wicked Dennis the Menace gleam in his eye, which we know is a sure sign he is about to pinch something. Unfortunately he can reach most surfaces in the kitchen: he'll use his claws like grappling hooks to try to drag the dish of frozen chicken necks onto the floor. He has become so adept at being able to reach things that we have had to find higher surfaces on which to put things out of his reach.

You may be wondering why the title of this story has a B in front of Bogey's name. To use slang, just in a friendly way of course, let's just say it

was not uncommon in the early years for one of us to say: 'You b----r!' and so he became known as B----r Bogey. Not polite, perhaps, but very appropriate. Many of our visiting friends call him B. Bogey as well, and it seems to fit his personality to a tee.

Bogey's got a few years under his belt now and is in the prime of his life. He looks magnificent with his long, shiny coat and that glint in his eye that tells you he is looking for a game. His one pet hate is when we try to start the lawnmower—he always starts barking frantically, and we have to tie him up until we've started the motor. After that he is fine. The trouble is that he has taught the others to bark as well and now it is almost impossible to hear if the mower has actually started over the din the dogs make.

Recently we bought a male pup from Victoria and we have had a litter of pups, two of which we have kept. They are only four months old now, but they've been watching Bogey pinch things—they seem to think it looks like a lot of fun and are starting to copy him.

So Bogey has a lot to answer for.

With the younger pups coming up into the show-ring, Bogey's show days are drawing to a close. Not quite yet, though. He will add a few more letters to his name when he is awarded the title of Australian grand champion.

Mind you, whether or not he gets his extra letters, he will always be the fun-loving B. Bogey to us, and it's very touching when he puts his head on our laps and looks up at us with that innocent expression in his big, brown eyes. It doesn't fool us for a moment, but we love him anyway.

Mike Posford

'No animal I know of can consistently
be more of a friend and companion
than a dog.'

Stanley Leinwoll

St Bernards, the Rescue Dogs

The amazing St Bernards were specifically bred by the friars of the same name to rescue people lost or stranded in the Swiss Alps. They were very large dogs, with massive heads: the biggest recorded dog was over six feet long and weighed 140 kilograms! It is thought they date back to the Molossoid breeds of dogs brought into the Alps by the ancient Romans.

Of all the heroic St Bernards to rescue people over the years, none was more famous than Barry (or Berry), who saved forty people during his lifetime and died trying to save the forty-first. The natural history museum in Bern, where Barry is on display, disputes this story. The museum writes that Barry was killed in 1814 by an escaped prisoner who thought the dog was a wolf. Ironically, it was the St Bernards' rescue work that almost wiped out the breed. Between 1816 and 1818 a series of severe avalanches killed many of the dogs that were used for breeding. To save the breed from too much in-breeding

they were crossed with Newfoundlands, but the heavy, long fur of the Newfoundland made them unsuitable for rescue work.

There is a monument to Barry in the Cimetière des Chiens. Books were written about him and Disney made a film about him. The Foundation Barry du Grand Saint Bernard was established in 2004 to take over the breeding of the dogs from the friars at the Great St Bernard Hospice, where the tradition of rescuing people from the snow had begun so many centuries before. Even today, the hospice continues to have a dog called Barry.

Candida Baker

Gilbert's Song

It's funny, isn't it? I sat down to write something witty and insightful about my dog Gilbert Jones, but every time I started, it just fell flat and ended up being neither insightful nor witty.

So I have decided simply to write what is in my heart about the wonderful fourteen years I had with this amazing character Gilbert Jones.

From the start, he stood out from the pack thanks to his huge upright ears, which for a Miniature Schnauzer are very unusual. I like to think that these gave him a special ability to listen to my heart and sense what I needed. So many times, he knew before I did that I was upset and many other times he was clever enough to know I needed to get out for a walk before I did. Come to think of it, the walks were probably more for him than me but that is the beauty of having a special friend like Gilbert Jones. Those boundaries

just blur into one another and both our lives were better for having the other one in it.

As Gilbert's mother, of course I think he was a very special and intelligent being. One particular talent he had that was widely recognised by everybody who knew him was his singing.

We often had dinner parties and, on occasion, I would throw my head back and howl to the moon. Gilbert would jump up on my lap and join me in the chorus with a beautiful heart-felt howl from the depths of his soul. This would prompt otherwise upstanding and rational people to do the same thing. There we would be with our heads thrown back and our chins forward, issuing forth amazing noises that sounded like the tuning of the world. This would continue for several minutes until Gilbert would stop and melt back into me, utterly exhausted.

The table would fall silent, and in some strange way we would all feel better. It was as if all the things we couldn't say as rational human beings had been let go with this most primitive form of song.

Gilbert would help us all release that which we didn't even know needed to be released!

Gilbert, his job of tuning his wolf clan done, would fall asleep.

I had many magical moments with him but for many other people this was the way they met and fell in love with him. I still miss him every day but I take strength from the fact that Gilbert and his song will live in my heart forever.

RIP Gilbert Jones—1997–2009.

Suzanne Jones

Faith's Story

At the top of her website, author, motivational speaker and teacher Jude Stringfellow writes: 'Faith was born for a reason. I believe it was to first heal my family from sorrow and sadness, and this allowed us to help her fulfil another mission—to help as many as possible.'

A bit like the beautiful Shetland mare Molly, who was a Hurricane Katrina victim and learned, against all odds, to walk on three legs, Faith the bipedal dog has expanded our human consciousness about what is possible—thanks to Jude, who never gave up on her.

Faith was born just before Christmas 2002. Her mother, Princess, a nearly full-blood Chow, gave birth to several puppies with deformities.

Faith, who had only three legs, was rescued by Princess's owner, Johnny, and his friend Reuben, when the boys realised that Princess was in the process

of smothering Faith to death, Princess knowing instinctively that her pup was not in a position to live a normal dog life.

Reuben grabbed the tiny, undernourished puppy and took her home to his mother.

Jude told me: 'She had three legs, but the left front leg was badly deformed, placed backwards, upside-down and had more toes on it than normal dogs have. The leg had to be removed when she was seven months old, when it began to atrophy.'

But Jude never doubted she could teach Faith to walk on her two hind legs, despite the seeming impossibility of the task and the advice of various vets who said the dog should be put down.

According to Jude, it was peanut butter that did the trick.

'We would use a peanut-butter-covered spoon to encourage her to hop,' she says, 'and our other dog, a Corgi, would bark at her to encourage her to move along.'

But it was Faith herself who decided to walk, giving the impression, in a video that can be seen on YouTube, of a strangely cartoon-like dog-person. Often Jude carries Faith by 'wearing' her around her shoulders. (Apparently

Faith is not the only dog to walk on two legs—there is at least one other, a Chihuahua in Texas—but Faith is certainly the best known.)

As Faith's fame has grown, so has her capacity to work as a therapy dog. Faith was given an honorary commission as a sergeant in the US Army in 2006, and her story is told to give encouragement to all the servicemen and women in the Armed Forces.

Faith visits grown-ups and children all over America, spreading unconditional dog love wherever she goes, and spreading, too, the idea that you don't have to be perfect to be perfect!

Candida Baker

'I think dogs are the most amazing
creatures; they give unconditional love.
For me they are the role model for
being alive.'

Gilda Radner

Brian the Farting Wonderdog

Brian the Wonderdog was big, black and boofy—with a fart that could peel wallpaper. One of his many skills, after letting loose, was to helpfully wag his tail to make sure the aroma hit his favourite human marks. He was so clever he could even surprise himself. After emitting a particularly loud one, he would turn around to see where the noise had come from.

Brian came to us from the RSPCA when he was about six weeks old. One minute he was in a cage alone, looking pathetic, his puppy tummy pushed forward for extra appeal, the next moment he was on the passenger seat of our car, sitting in his poo. It was his ears that drew me in—they were so soft you wanted to sleep in them.

It took Brian a while to master the dog door when he came home. We had to take half the door out so he and the quilt and/or pillow he always greeted visitors with would all fit. Sometimes he'd greet people with bits of

other people's clothing, other times with something unrecognisable but always damp—and never without that loopy Labrador grin.

He'd bound up with the same joy to people he loved and those he'd never met before. He'd bark at everything, particularly if it was happening in the next town.

His greatest gift was to find the deadest, stinkiest thing he could when he took us for a walk and then—tired out by walking for ten minutes—race home, leap onto the bed with his smelly new best friend, and start snoring.

He was petrified of cats, would run to the other end of the house if he thought there was a mouse under the fridge, and he could hear a can opener from 100 metres away.

Brian was a dog of many talents. His particular skills included eating almost-completed tapestries, anything expensive and everything that belonged to visitors, and remarkably selective hearing.

He was also generous. When Lassie the Blind came to live with us, he taught her everything he knew. She, understandably, fell for him—mainly because she couldn't see a thing—while following him about the garden and straight into trees, the wheelbarrow or the pony.

His favourite pastime was to work on his hole to China. He would wait until Lassie was right behind him before he seriously started digging. She would stand there patiently, wondering why it was raining dirt. When we gave Lassie her summer haircut—which usually involved whoever was home and as many blunt pairs of scissors as we could muster—Brian would lie down next to us and erupt in a continuous chortle that was clearly no bark. The saving grace was that Lassie couldn't see what she looked like after her trim.

I don't know if it was his constant aroma that kept her glued to his side, but she loved him like a bone. 'He is her eyes,' one of us once said. She trusted him implicitly. When she heard her favourite humans coming home, she'd race towards their sound, often taking to the air in her excitement.

Every time, Brian was there as her fall guy.

Towards Brian's end, at age fourteen, we moved to a property with more acres than he could dream about cocking a leg at. Sadly his legs had pretty much stopped working by then. He would open one eye when we'd head off for a walk, come as far as the gate, and settle down for a snooze till we came back.

His heart was giving out and so were most of his other bits. His breathing sounded obscene and he rattled with medication. In the end the hardest thing

was not trying to stop him eating underwear, howling at the moon, pissing in shoes or taking dead things to bed. It was letting him go.

Sally Hopman

'Properly trained, a man can be dog's best friend.'

Corey Ford

My Dog Izzy

Etta's room was at the back of the nursing home, 'all the way to the end, on the left', said the manager coolly. Nursing-home administrators, like some doctors and even family members, aren't always happy to see hospice volunteers, whom they sometimes see as harbingers of surrender.

I unleashed Izzy, my golden-eyed, five-year-old Border Collie, rescued from an upstate New York farm. He now lives on my upstate farm, where he's my resident soul mate and shadow. He's what I call a spirit dog—he takes you places you don't necessarily know you're going.

Izzy and I became volunteers together last summer, after weeks of rigorous training by the local hospice. Volunteers are an integral part of the hospice philosophy, but they have to be taught to behave differently than they might normally—to listen rather than give advice, to accept the reality of death rather

than try to cheer everybody up, to be comfortable with the fact that patients will not recover. Never, for example, should we tell a patient or family to buck up, move on, or cheer up. Generally, things do not get better.

While the hospice workers at the hospice and palliative care program are always looking for ways to make patients more comfortable, they weren't immediately certain that a dog would make an appropriate hospice volunteer. They had to ponder the insurance and health implications, and the particular sensitivities of hospice work. What, for instance, would be the consequences if a dog bit a patient or, heaven forbid, ate his medication? My vet had to testify to Izzy's temperament, confirming officially his gentleness and responsiveness.

As it turned out, he is a natural. I was the one who needed all of the training.

We headed down the corridor, Izzy walking beside me, watching for cues. Etta's room was a large one, with a hospital bed and a dresser topped with old photos. She was eighty-six, the last surviving member of a family that had farmed in our area for 150 years. She'd had dogs on her farm for years and loved them. Now she was suffering from advanced colon cancer and dementia.

She had outlived all of her friends and had no visitors apart from the hospice social workers and nurses—and, now, Izzy and me. In private homes the dying are often comforted and surrounded by their families. In nursing homes, they are often alone.

Etta sat in a wheelchair, clutching her side, moaning occasionally, saying she was going to the hospital. She barely seemed to notice when I came to her door.

She was nearly phobic about being touched, the nurses reported, making it difficult to clean and care for her. She sometimes struck people. Now she was 'actively' dying, a term used to warn volunteers that she wasn't expected to live long.

I announced cheerfully that we were there, that I had a dog with me. As is often the case in short-staffed nursing homes, there was no one around. In the three months since we started doing hospice work, Izzy had learned to spot and head for wheelchairs and hospital beds. His gifts as a volunteer are multiple: gentleness, appropriateness, patience. He never pesters anybody or goes where he's not wanted. He can remain still for many minutes. When he's not wanted, he finds a corner to curl up in and makes himself invisible.

He approaches people in pain, people in comas, people with dementia and paralysis, disfigured and frightened, always softly, carefully, and lovingly. He threads his way around IV apparatus and oxygen tanks. I've never had a dog that could do this kind of work, nor could I begin to imagine how to train a dog to do it.

This time, though, as Izzy came to Etta's right knee, she cried out in alarm. Her hand jerked forward and she swatted him sharply across the nose.

Izzy was surprised. He backed up quietly, looked at me, and sat down. I rushed over, concerned about how he might react, but he seemed composed, calm. I talked to Etta, trying to reassure her, though she probably didn't understand. I remembered my training. Speak to people as if they do understand, even if you don't think they can. Because they might.

'Sit down, sit down,' Etta kept pleading, as if she were at some level trying to be hospitable.

Izzy inched forward again, and again her hand lashed out—but this time, he was ready, and he quickly backed away.

I kept talking to Etta, asking her how she was, as she clutched her stomach.

Izzy was watching carefully. When she put her right hand on her knee, he made his move, slithering toward her and placing his nose beneath her hand.

She froze as if shocked, and her eyes widened. Her mouth opened, but no words came out. I saw her hand close over Izzy's slender nose as he sat stock-still. A slight smile came over her worried face, and she visibly calmed. 'Oh,' she said softly, with pleasure. 'Oh. It's a dog.'

Izzy didn't move for at least ten minutes. Neither did Etta. She moaned still, but more softly.

One of the aides came in on her rounds and looked shocked. 'My God,' she said. 'That's the first time I've ever seen her smile.' She called for help from another aide. While Izzy and I stepped out into the hall, they got Etta up, changed and bathed her, got her into bed. By the time we came back in, she had fallen asleep.

So we went back down that long hallway.

'What a beautiful dog. I wish he could be here all the time, but he's better off with you,' one of the women told me. 'Don't let him stay here.'

Izzy and I have visited many patients now, and the hospice people are right. It's sad to see somebody die. But it doesn't have to be depressing. Sometimes it can be beautiful, quite powerful, especially when the dying person is comfortable and cared for, and has a sense of control.

Izzy has his rounds, patients who wait for his visits. There's a six-year-old boy with a brain tumour; Izzy puts his head on the boy's chest, and the two lie together for long moments while the boy strokes Izzy's coat. A man with bone cancer asked to see Izzy just before he died. When Maria, an eighty-year-old Alzheimer's patient who was one of Izzy's favourites, died, her daughter asked if Izzy could come and pay a final visit to the home. He hopped into Maria's bed and lay still on her pillow. Maria's daughter burst into tears.

I don't really know why Izzy brings such peace and pleasure to people in their final days and hours. There is little research about this kind of interaction, and I prefer to keep it a mystery. Maybe the people are remembering the dogs they loved as children. Perhaps the gentle touch is what matters, what gets through to them.

Whatever the reason, I see the same thing over and over. People startle, then smile, and the tension drains. They grow more peaceful, feel safer. There are some things experts and studies can't explain, even in our soundbite-obsessed culture.

When I think of my work with Izzy, I often think of Sam, a middle-aged man dying of cancer who was pale and weak but alert, even cheerful. When

we entered his house, Izzy would trot toward Sam purposefully, making strong eye contact, his tail swishing.

The last time we saw him, Sam laughed softly as he saw Izzy coming, and he put his hand over Izzy's head, scratching it softly. As Izzy sat by him, he closed his eyes, and leaned back in his chair. Everyone in the room was mesmerised by the palpable connection between Sam and my dog.

After a few minutes, we said our goodbyes. When Izzy paused, turning as if he had forgotten something, he returned to Sam for a final pat. 'Izzy, thanks,' he said. 'See you on the other side.' We didn't see Sam again.

Jon Katz

Sleepy the Splendid

A few years after I arrived in Australia from England, I was living in a small inner-city terrace in Sydney that, coincidentally, was around the corner from a friend's house. She had two dogs—Scruffy, a very scruffy terrier of indeterminate lineage, and Sleepy, a Fox Terrier puppy who was about to outgrow her name in a dramatic way.

Joanne didn't really have the time for a hyperactive puppy hell-bent on creating havoc, and when I offered to walk both the dogs for her she accepted with gratitude. It suited me since I loved to walk anyway, and walking with dogs has almost always been a pleasure (with one of our dogs, Ella, being the notable exception to the rule).

So Sleepy and Scruffy began to join me on my daily walks. From the very start, Sleepy showed what a bright and intelligent dog she was, learning almost instinctively to heel, to come when she was called, and to stay out of trouble.

Scruffy, on the other hand, who had been left to her own devices for some years, showed she was completely unfamiliar with walking etiquette. She would try to chase motorbikes, cars, horses—anything that moved, really—under the mistaken impression that they were all in her territory. But she too was a good dog, and after a few strict words, she settled happily into our walking routine.

I would pick them up from Joanne's house and drop them off again, but it soon became clear that Sleepy would rather stay with me. When Joanne offered her to me, I jumped at the chance to own this lovely little tan-and-white Foxy with a heart of gold.

She became my constant companion. At that time I was riding in the park early in the mornings, and Sleepy would heel beside the horse as we went through the busy streets we had to cross to get into the park. While I rode, she would run along at a respectful distance, never once coming too near the horse or running too far away to make me concerned.

Without even thinking about it, I started asking her to do harder and harder things. She would come into the city with me, run up escalators, and then jump into a basket so I could carry her around while I shopped.

Sometimes, after we'd finished our walks—and in those days the park was often very empty early in the morning—I would give her a run behind the

car. She would speed along beside me, then, when I slowed down, jump in through the window as I was driving along. She could jump in and out, but would never do either until I gave her the order.

I often used to ride in the country as well, and Sleepy would come with me. She would show her enormous heart by always being first home in front of the horses, no matter how long we'd been out.

But being a little Foxy, she wasn't a tough dog. She liked nothing better than to snuggle up on the sofa with me or anyone else who would give her a cuddle, and she was besottedly in love with a very handsome male Foxy who had exactly the same build and markings as her but was black where she was tan. I remember his name was Butch, but I don't remember the name of his owner, who was an old park regular with whom I took to walking whenever we bumped into each other so that Sleepy and Butch could run rings around each other for an hour or so.

Butch's owner was fond of betting on the horses, so we often talked of racing. I think he liked the odd drink, especially after a successful visit to the racecourse, but he was absolutely devoted to his dog, and walked him come rain, shine or hangover every day.

Scruffy couldn't come riding with me because she was not as obedient or as fit as Sleepy, and she didn't come on our country adventures either, but she did come to the little beach house I rented. Both dogs learned to love the river and the beach, and the beautiful park that was directly in front of the house.

One day Joanne rang me up to tell me she and her husband had decided to move to Queensland, to Yeppoon to be precise. Joanne wanted to know if I would give Sleepy back to them because they both felt that Scruffy would pine for her, and because they were moving to a house with a big garden, with bush all around so the dogs would have a happy life.

To say I was torn is putting it mildly.

I loved my little dog so much I couldn't bear the thought of parting with her, but my career was taking off. I was working longer hours. I had less time to walk and ride and adventure. In some ways it almost seemed as if it was meant to be—I had walked and loved the two dogs for several years, and now Joanne and her children would walk and love them both and they would have a freer life out of the city.

If the same thing were to happen to me today, there is no way that I would let her go. I had not yet understood that when an animal chooses you, you

belong to it, as much as it belongs to you. I think I felt that I did not deserve to keep her, that if I did keep her something would only go wrong anyway, and that she would be better off without me, that love never lasts, and that it's better to say good-bye sooner rather than later.

Based on all that strange, out-of-shape reasoning, I decided Sleepy should go back to Joanne and the family—and, of course, to Scruffy, who would be much happier with her little companion.

When I next saw Butch and his owner in the park and told him what was happening, he was horrified: 'There's a dog-baiter in Yeppoon,' he said. 'It's even been in the papers.'

He was sad for Butch as well. 'He'll pine for her,' he said. 'It won't be the same without her.'

'I know,' I said, and, echoing an often heard grown-up expression that always meant the opposite, I said, 'It's all for the best.'

Even now, thirty years later, long after Sleepy would have left this earth anyway, I still can't write about the day they came to collect her without crying.

She did not want to go.

She knew without a doubt that something was up, and cowered under the furthest recesses of a large lounge chair refusing to come out, until I had to move the chair, pick her up and hand her over.

And so I gave away my precious little dog. Afterwards, I missed her so much that sometimes I fantasised about hopping on a plane to Queensland and retrieving her. But whenever I spoke to Joanne, she said Sleepy was happy and Scruffy was too, and so I gradually settled into a Sleepy-less existence.

Six months after they moved, I got a letter from Joanne. It was around Christmas time so I thought it was a Christmas card—but it was the reverse of happy news.

She had let both the dogs out one morning for a walk, and Sleepy had eaten poisoned bait. She had died only a short time later, locked in their laundry after Joanne, who of course did not realise what had happened, had gone to work.

So my friend from the park was right—there was a baiter at work in Yeppoon. And my instinct that I should not let Sleepy go was right, and she had died an agonising death.

A few weeks later, while I was still raw with guilt at the idea that I had caused her death, a friend's partner who knew nothing of Sleepy told my

friend: 'I keep seeing this small brown-and-white dog with tan ears and she's trying to tell me something, something about it all being all right.'

My friend knew immediately that it must be Sleepy her partner was seeing, and she rang me to tell me. Hearing it did help a bit, though not much, to be honest.

I sometimes wonder if, when you die, your most beloved pets are there to meet you along with your human spirit guides. If so, I hope that Sleepy will be there, waiting for me.

Candida Baker

They Do Love Me!

I used to live on acreage with a Corgi cross called Hey Dog who'd needed a home. We were very happy together. Sometime later, my parents built on the property next door and moved in, so Hey Dog and I had more company.

Eventually I developed a relationship with a man who got himself a black Staffy (Staffordshire) pup for his birthday. He didn't always look after Ricky well, but as she wasn't my dog I found it hard to intervene. His goal was to train her to be a pig-shooting dog, so she was always getting lost and injured in the bush chasing something. She was a tough little thing.

Poor Ricky ended up pregnant well before her first birthday. The day she went into labour, the man left Ricky and me to attend a family wedding. She had a terrible time; she had to have a Caesarean and later lost her stitches and had to have more emergency surgery. She desperately missed her owner. I slept beside her and the pups on the laundry floor for quite a few nights, worried that

she was simply going to give up. She did a great job as a new and young mother but I was always mindful that she wasn't mine and treated her as if she was just boarding with me rather than giving her the care I really wanted to give her.

When her owner turned up again, Ricky wouldn't give him the time of day. He'd left her in distress too long. They both knew it. He sold the pups and gave me the money to cover all the vet fees I'd paid. He kept a fat white pup he later named Bundy. Ricky stayed with me and Hey Dog while Bundy moved away with the man.

Six months later the man turned up again. Bundy had grown into an extremely nervous and unwell-looking dog. He'd developed epilepsy after being hit by a car. He was on the highest dose of medication he could tolerate. He was a walking zombie, scared by the slightest noise. The man rejected him because he didn't know how to manage his medication or his fits. He wanted a rough, tough, blokey kind of Staffy, while Bundy was a lost and needy soul.

So the shadow that was Bundy came to live with me, Hey Dog and Ricky. When I wasn't home, all three dogs went next door to my parents'. Bundy was very high-maintenance, and though I gave him lots of attention, I was never sure how he felt about me. He panicked about so many things that it felt to me as if I would never find a way to connect with him.

Sadly Hey Dog passed away not long after Bundy arrived. Ricky in particular mourned for him for a long time. But she was a tough, independent dog and didn't want to be coddled.

When Bundy had been with me for a year and Ricky had been with me for almost two months, I had an accident.

I'd had the flu and had decided to go and visit Mum and Dad and get a bit of sun. I went to walk down my front steps with a cup of soup in one hand and a bread roll in the other. The dogs were close by, hoping for a bit of soupy bread. But instead of going down the steps, my leg went between them and I toppled over, hitting my head on the brick wall to the side and then on the paving stones before passing out.

My mother later told me that Bundy turned up at their house making crazy noises, running to and from the direction of my property, and grabbing at their clothes with his teeth. Very bold, un-Bundy-like behaviour. So they decided they'd better follow him.

When they found me on the front landing, Ricky was sitting quietly beside me as if on guard. Also very concerned, un-Ricky-like behaviour.

My parents lifted me and carried me into the house. Mum used to be a nurse so she checked me over while we waited for the ambulance. She said

the dogs were keeping a respectful distance and didn't touch the bread roll or the soup spilled on the landing until after I was awake and talking again.

We were all astounded by the dogs' behaviour. One had watched over me (not the free food!) and one had gone for help. Living alone in the country, I could have been unconscious for a very long time before someone discovered me. And I was too injured to be able to get up and phone for help even if I had woken up.

It took a very long time to recover from the accident, having badly injured both legs, an arm and my head during the fall. Once I was back home, Ricky and Bundy stuck to me like glue, showering me with kisses and happy Staffy talk, and I couldn't cuddle them enough. I realised that despite their bad start in life, they had now become 'my dogs'. I think we all finally understood it was OK to love each other, because no one was going to come and take them away again. Whatever happened from now on, we would be looking out for each other. We'd created our own little dysfunctional family!

Bundy lived to be thirteen before I had to put him to sleep after one of his panic-induced incidents in which he severely injured some nerves in his spine. Ricky is still going strong at almost sixteen.

I did get another white Staffy after Bundy, mainly because Ricky was not doing well on her own and there was a pup needing a home. Her name is Stussy (she chose it herself) and I love her to pieces. Sometimes I call her Bundy by accident. I still think of him all the time, and now I know for sure that he loved me as much as I loved him.

Alyson Dean

'Did you ever notice when you blow in a dog's face he gets mad at you? But when you take him in a car he sticks his head out the window.'

Steve Bluestone

Missing Mutts

Oliver, aged twelve, the arthritic patriarch of the family, and his nubile two-year-old Labradoodle girlfriend, Honey, went missing. Although this was unusual, we were sure they would return by dinner time.

After twenty-four hours had passed, we started to get a little concerned. Oliver never left the property, so it was obviously Honey who had led him astray.

Another twenty-four hours went by and now we were door-knocking the neighbourhood and sending out friends on search parties. We were hearing stories of packs of wild dogs, poison bait and the rest. After three days, we were pretty much resigned to an unpleasant outcome. Oliver could hardly get up our drive, let alone wander foodless for three days in winter.

On Day Four I received a call from a farmer several kilometres away. He said my Labradoodle had wandered up to his house. I tentatively asked if there was only one dog, and he said yes.

My sorrow was mixed with a deep anger that Honey had led Oliver to an undoubtedly slow and painful death.

The kids and I donned boots and rain jackets and set off on the grim task of searching this man's farm for what remained of Oliver.

When we got there, we saw Honey tied up with the other farm dogs She was very excited to see us and so I tried not to show my anger.

Minutes later, the farmer pointed down the road to his tree plantation. 'Do you have a white dog?' he said.

I looked up to see Oliver limping towards me up the long driveway. He was several kilos lighter but alive. The way we all cuddled him, it must have looked like a scene from a movie where the hero returns from war!

Neither dog ever left home again.

Ruth Gotterson

'I think we are drawn to dogs because they are the uninhibited creatures we might be if we weren't certain we knew better. They fight for honour at the first challenge, make love with no moral restraint, and they do not, for all their marvellous instincts, appear to know about death. Being such wonderfully uncomplicated beings, they need us to do their worrying.'

George Bird Evans

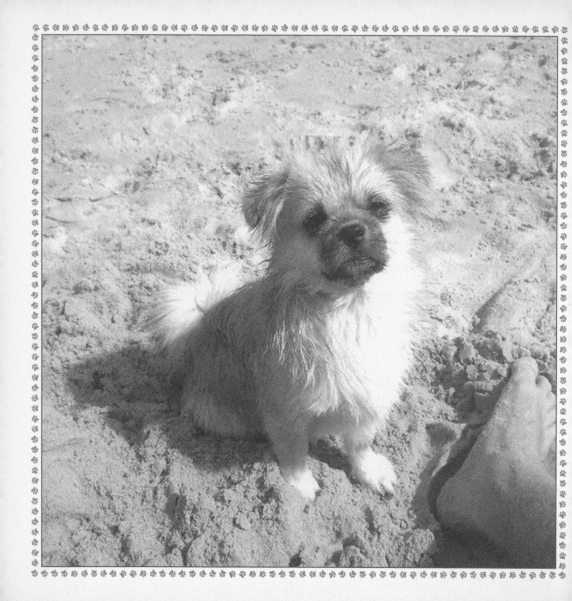

Dogs Must Be Kept Under Control

One day, as the result of some increased sternness of attitude by the park administration, the park is suddenly covered with signs—some brusque, some informative to the nth degree.

Big patches of the park are suddenly dry and brown. Signs say 'Noxious Weed Removal. This area is being cleared of noxious weed. The removal programme involves six species, including lantana, blackberry and pampas grass.'

Other signs warn walkers about the branches of coral trees falling on their heads, ('They are in decline and dangerous') or warn drivers of the severe fines for driving over 30 kilometres per hour.

In the area of the park where dogs are allowed to run free there are new signs saying 'Dogs Must Be Kept Under Control'. This is rather like putting

up a sign saying, 'Men Must Be Rich'. To be earnestly desired but not in the realm of possibility.

How to let dogs run free and simultaneously keep them under control is the problem.

During this period of increased park-ranger officiousness, a female ranger screeches to a halt in her four-wheel-drive and approaches me when I'm in the middle of a park dilemma.

My four-year-old, a long way from a lavatory, is mortified at having had an accident in his pants. I'm kneeling in the pampas grass trying to deal with it. At the same time, Ella has just discovered half a dead possum fifty metres away, a strip of rigid fur and bones, and is beginning to munch on it.

'Control your dog!' the ranger shouts.

'In a minute,' I say, looking up. Oh, God. 'Anyway, she's not out of control. She's standing quite still, eating.'

'She's eating a possum!' says the ranger.

'A dead possum,' I point out, over my little boy's embarrassed wails. He's dragging me towards the car to cover his mess and shame, to get him quickly home.

'That possum could be alive!' says the ranger.

186

'But it isn't.'

'Don't walk off while I'm talking to you!' shouts the ranger, confusing herself with a police inspector.

'It's as stiff as a board. It's as flat as a pancake. It's been run over by a car. It stinks. It hasn't got a head. It's been dead for weeks. You're not suggesting she killed it?'

'Well,' says the ranger, revealing an ignorance of dogs' bizarre fondness for meat, 'she shouldn't be eating it. Women and children don't like to see that sort of thing.'

I can't help glancing around and asking, 'What women and children? Where?'

Why this gender favouritism? Why these sheltered sensibilities? Is she talking about herself?

'Control your dog!' the ranger yells, 'or I'll take your name and address. You don't have control of your dog!'

And this rapidly escalating episode, somewhere between *Catch-22* and *Monty Python*, suddenly comes to a conclusion.

Tense and harassed, I give one sharp whistle. Ella drops the corpse like a hot coal, sprints towards me and leaps—like a perfectly trained circus dog,

like a dog in a dog-food commercial, like heroic Lassie or Rin Tin Tin—onto the back seat of the car.

And although the car's interior is gaggingly pungent, what with Ella panting her carcass-breath down my neck and my child's accident seeping into the upholstery, it's with a rare light heart, not to mention the quiet pride of the dog owner, that I drive out through the park gates.

Robert Drewe

The End of a Wonderful Era

This piece was written by guide dog stud dog Phil, aka Finn MacCool (10 July 1994—12 February 2009).

I don't remember much about the Owenstown horse stud where I was born in northern County Kildare, Ireland. My mother lived there and that is where I was first registered as 'Owenstown Troy'. When I was eight weeks old, I travelled with my siblings to the Guide Dogs for the Blind Association, where our father, Guidewell Gunner, was a stud dog. We were renamed the P litter, and I became Phil.

When I was eighteen weeks old, my brother Pierce and I became the last pair of over 30 potential breeding stock to fly to New Zealand. After thirty-two hours in the plane, with one brief stop in Singapore where our water was replenished, we landed in Auckland. I heard Breeding Services manager Wendy

say, 'Quick, open the crate, get the collar and lead on, and run for the grass!' Pierce and I ran, then peed, and peed, and peed.

Following our puppy training, Pierce became a guide dog, and I was selected as breeding stock. Besides my work, I've had all sorts of adventures. Once I posed for a magazine and got to hold the arm of a beautiful girl. I was the only dog of the six candidates there who would hold her arm in their mouth, but by then I'd had lots of practice holding and carrying underwear and socks onto the front lawn at home.

My first birthday was spent in the ski fields near Queenstown as we helped to raise enough money for two guide dogs for the Lakes District. An ice carver made a hollow sculpture of me and skiers dropped money into it.

I've been driven and flown up and down New Zealand many times, and attended more yachting regattas than I can count. I liked it best when we went camping and there are several photos of me poking my head out of the tent in the morning. Christchurch was my favourite airport. I knew my way to the basket of soft toys for sale, and I was usually allowed to choose one.

When I was ten, I won Grand Champion at the Fun Day, and last year I won oldest dog, and went in the fancy dress as The King. I specialised in the 5-kilometre walk at several Masters Games. What I really enjoyed most was

having the guide dog puppies to stay for about a year. I trained several German Shepherds, a few Labradors and crosses, a Border Collie, some more Golden Retrievers, and my favourite, my son Zinzan.

Not so long ago I was walking slowly around the stadium when a man stopped and said, 'I don't really like dogs, but your smile makes me want to pat you.' Ten minutes later, a beautiful teenage girl walked past, then turned and came back, took my head in her hands and said, 'You are sooooo gorgeous.'

Ah . . . Even in old age, I hadn't lost my touch.

Last year we said goodbye to Finn MacCool. It was a privilege and a pleasure to have shared nearly fifteen years on this earth with this remarkable dog. His line will continue thanks to the use of frozen semen; his latest litter of six pups, conceived by that method, are now a year old.

Marilyn Valder

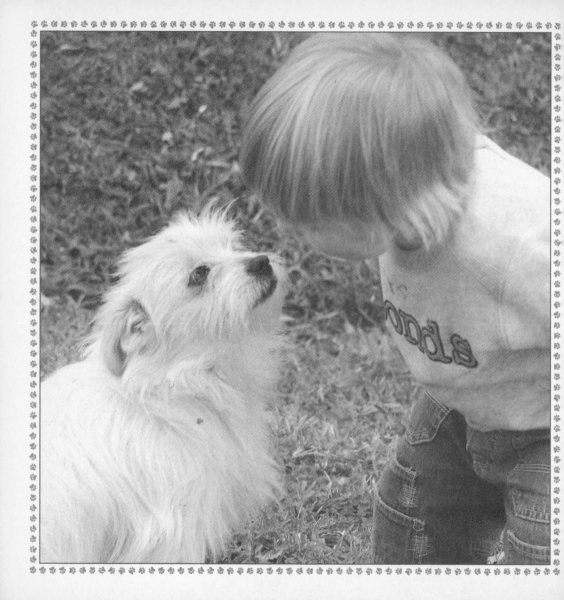

Happiness is Dog Shaped

You never see an unhappy well-treated dog. Dogs seem to have this absolute joy at living in the moment.

I have two adorable Jack Russells who both came into my life thanks to a chocolate Kelpie.

Chocolate (such an appropriate name) was a loyal, loving companion, and for most of my teen years she was my best friend. Born and bred in our family, she was the first dog I called mine. She was mine to train, mine to feed, and mine to love. And love her I did. As a young pup, she was very alert, and training her was a breeze. She was so well trained that if my father asked her to sit, she would look at me to get a nod of approval before following the order. We were an inseparable team.

When I moved out from the family nest, I took Chocky with me. Our new neighbours had a couple of dogs who one day decided to dig through to

our yard under the fence. I doubt Chocky gave more than a moment's thought to staying behind before following them into the big wide world. I came home to find she was gone and that she had taken my housemate's dog with her.

After about a week of scanning empty paddocks and driving in my car around the neighbourhood for any sign of my best friend, I had to give up hope. I felt as if I was drowning in tears, and eventually I couldn't take the emptiness any longer. I decided that the best thing for me to do was to get another dog and if Chocky came back, well, I would have two. And that is how I came to get my first Jack Russell.

My boyfriend and I went to the local pet store. There in the front window was the tiniest Jack I had ever seen. She was the only one left in the litter and was shivering from the air-conditioning. I picked her up, and she sat in the palm of my hand. We didn't have to look any further—we had found our girl. So we took her home, named her Miss Jackie, and started our new life with her. To this day she is the tiniest Jack I've seen—weighing in at just over four kilograms of pure dynamo.

About a week after we got Jackie, I had a frantic phone call from my brother, who had moved back in with my parents. They lived about 15

kilometres from where I lived. He had found Chocky and her friend running along the road. She had managed to wind her way through the local creek system from my place, back to the home where she was born. And she'd made sure her friend stayed with her. I was so glad to have her back, even though she smelt like a swamp rat. I had never imagined having two dogs but my boyfriend and I quickly adjusted.

Last year when I lost Chocky to cancer at the age of fifteen, it seemed appropriate that she should be buried near the spot of her great adventure. I was completely lost without her; I cried many times and I still find it hard to accept that she's gone almost a year later.

But her death led me to my next Jack.

About a week after we buried Chocky, I started looking on the internet. I was prepared to travel to any corner of the country to find just the right dog to keep Jackie company and to join our family. Then I saw an advertisement for Jack Russell pups for sale about an hour's drive up the road. I couldn't believe my luck. I immediately jumped on the phone and was told by the lovely lady that I could come up and take the last puppy they had—a cute, cuddly little girl.

The day before we went to pick her up, I was lying in bed, thinking of possible names for my new friend. Suddenly it just came to me. 'Missy,' I said to my boyfriend, and we both agreed it was a suitable name.

When we got to the house, we were welcomed by the family, who were keen to see their last 'baby' go to a good home. As soon as I picked Missy up, I felt an incredible bond with her. She pushed her little body into my chest and nuzzled her head into my neck. She was ours. When we went inside to seal the deal, the lady told me she had first decided to have Jack Russells when her Kelpie, who was named Missy, passed away. I don't believe that's a coincidence.

Every day now, I thank Chocky for introducing me to my two girls. If it wasn't for her, I'm pretty sure the seemingly perfect timing of each event would have been askew, and I would have missed out on both of these precious dogs.

For my two Jack Russells, it really is a dog's life. They have it all—hundreds of toys, two cats to play with, air-conditioning left on for them on hot summer days, and even cartoons to watch on TV when their parents go to work.

They get to push us out of bed if they get uncomfortable during the night (even though we tend to push back). And there is nothing like waking up with a dog in your face to console you that your breath can't smell that bad!

196

Plus, after you've had one of those days from hell at work, a dog's kiss simply licks all the stress and pain away.

That's why I love my dogs. I can truly be myself around them because they love me just the way I am.

Tonia Moorton

'A door is what a dog is perpetually on the wrong side of.'

Ogden Nash

Our Madcap Friend

I dreamed her first, long before I saw her.

I was pregnant with my first child, and had three step-children who spent a lot of time with us. I wanted all of us to have the experience of a puppy, and my child to know the delights of growing up with a faithful canine companion.

I diligently researched the breeds. I wanted a short-haired dog, one that would bond with everyone—not a one-person dog, good with children, a real family dog. At that time, German Short-haired Pointers were enjoying a burst of popularity, which I believe has since eased off, and perhaps by the time you finish reading this you will understand why!

My previous dogs had been mutts. This time I wanted the special dog. I didn't want to get it wrong. *Hmmmm.*

It was when I was doing my dog research that I dreamed of her: a beautiful liver-brown Pointer, running ahead of me (well, that part turned out to be true), as happy and joyous as a dog could be.

So it was that a few months later, much to the disapproval of my husband, my step-children and I went to pick up ten-week-old Ella.

She was adorable, all shiny and silky, with huge floppy ears and paws, and we all cuddled her to pieces.

That first night in her new house, she howled and howled and howled, crying like a newborn baby so piteously that I visited her several times to administer comfort, which of course only increased the volume of the crying when I left her bed for mine. And that, dear reader, was the start of it. Three nights of howling from Ella and complaints from the neighbours began a lifetime of trouble with a capital T, or in Ella's case with a capital E.

The warning signs were there right from the start—had the breeders seen us coming? There was, for instance, her total lack of desire to come when called. Instead she would cock her head, as if considering the question for a moment, decide against it, and continue on her merry way.

When Ella was still very young, only about five months old, she slipped off the lead at the last minute as we were arriving home from a walk and

raced off into the busy streets near our home. I immediately set off to look for her but it was as if she had disappeared into thin air and after a few hours I was convinced she must have been run over or stolen, or got completely lost.

Just as we were giving up hope, there was a knock on the door.

'Do you happen to own a brown dog?' the woman asked me.

'I do,' I said. 'Have you seen her?'

'Well, yes,' the woman replied. 'She's in my house asleep upstairs on my bed.'

Our neighbour, who had been out gardening, had left her front door open, and Ella had managed to get herself within three doors of our place, when obviously the lure of a beautifully fitted-out queen bed seemed far more appealing than the kennel in the backyard.

One day when I was heavily pregnant, Ella came burling up behind me in the park, and delivered a huge blow behind my knees that buckled me to the ground. As I lay there groaning, belly up towards the sky, I knew we were in serious trouble. Never mind that I was a religious dog-walker or that all my previous dogs had been well behaved. Ella was exuberant, headstrong and out of control. She might come, if you were lucky; she might sit if she wanted

to; she might not run away. But she was far from the placid canine companion we had imagined.

Shortly before the baby was due, my stepson and I were at our beach house alone and we decided to take Ella for a walk on the beach before driving back to Sydney. Ella immediately left the part of the beach where you were allowed to walk dogs for the area where dogs were banned, throwing herself all over complete strangers while I called her in vain. Knowing full well she was in trouble, she danced out of our reach while Jack and I got more and more furious. In the end he gave up and sat on the sand while I put into action the only strategy I could think of. It wasn't comfortable running when I was nine months pregnant, but after seeing me apparently running away from her Ella finally concluded that Mother might be disappearing for good, and she'd better chase after me. Just as she was about to bowl me over, I lunged for her and grabbed her, squishing her into the sand with my oversized and rather sore belly.

We had a family conference and decided that some training would be a good idea, so just before the baby was due to be born she went for dog training for a few weeks.

Let's just say it didn't take.

I don't know what methods they used, but all that seemed to happen was that Ella developed a life-long fear of balloons and umbrellas, and an even keener sense of when to disobey orders.

Another of Ella's foibles was a very strange attraction to nappies—the dirtier the better. One day, on my way out of the house, I carefully placed a small bag of disposable nappies in the garbage bin in the backyard near Ella's kennel. On my return, I found a note from my husband: 'Ella is a bad, bad dog, and must be punished. I have taken her for a walk. R.'

Ella had pushed over the bin, found the nappies, taken them into her lair, and proceeded to shred them. The stink was beyond belief.

When our son Sam was six months old, I took my first long drive away from home with him and Ella, over the mountains to visit my oldest friend. It was a fraught trip from the start—the car broke down only forty minutes from home, and by the time I reached the Blue Mountains I was exhausted. I decided to stop at a café for lunch—it had a large park-like garden, so I figured it would be easy to give Ella a short walk there, and feed both me and the baby. I should have known better.

There was a small blue bucket in the garden, so I put some water in it for Ella while we went inside to purchase something to eat.

When I came out five minutes later, Ella had torn the bucket into shreds. Fortunately no one was around to witness her crime, so I quickly picked up the pieces and put them in a bin. Keeping her on the lead, I walked to the furthest part of the garden, away from everyone, and settled down for a picnic. Ella managed to haul away from the tree branch I had tied her to, and headed off at high speed around the garden—nose in the air, so I knew she could smell something—and with an uncanny instinct for the most disgusting thing in the place, she found a discarded nappy. So there I was, chasing Ella around the gardens to no avail while she danced about, dropping her catch only when she passed my lunch, which she devoured in two seconds flat.

Finally, more by good luck than anything else, I caught the dog, managed to eat and drink something, changed the baby and got back in the car with a sigh of relief. I gave Sam a dummy, figuring it might soothe him into having a nap, and headed off again. A few minutes later a startled cry burst from the back seat. Glancing in my rear vision mirror, I saw Ella gazing nonchalantly at the passing landscape, the dummy in her mouth.

The words 'Ella' and 'bad dog' went together so easily. A few months later, when Sam was nine months old, I took him and Ella to the park for a stroll—or at least, he and I strolled while she galloped wildly around

looking for trouble. She found it in a bag with—you guessed it—a discarded baby's nappy inside. She then proceeded to dart away from me, simultaneously tearing up tiny shreds of stinky nappy and scattering them across the pristine grass carpet.

'Bad dog!' I yelled at her uselessly. 'Bad dog. Come here. Bad dog.'

Sam was taking a keen interest in proceedings, sitting up very straight and straining this way and that to keep his errant friend in sight. As she hove into view, festooned with trailing nappy bits, he yelled out happily, 'Badog, badog, badog, badog . . .' Thus my darling child's first words were not Mum or Dad, or anything sweet and loving, but a fierce scolding that he kept up all the way home, while Ella sat on the seat, her stinky breath perilously close to his precious head. 'Badog, badog, badog . . .'

Not long after that episode I decided to buy a station wagon with a dog barrier.

The fact was that Ella loved anything that smelled. The worse it smelled, the more she loved it. Over the years she devoured, at various times: an entire dead pelican; a possum that had been dead for so long it was green and mouldy—carrying its remnants in her teeth for days (even after I took to her mouth with a brush, a hose and a hefty dose of toothpaste); a dead

fox with extreme rigor mortis; a rabbit with myxomatosis—which I hardly need add, caused her not a moment's bother; and several department store bags, which eventually presented themselves from her rear end in a most unsavoury fashion.

This was apart from human food, which she could devour in a few seconds flat. She was very fond of park picnics, particularly treats such as BBQ spare ribs and very old pizza.

By the time Ella was two years old, she could outmanoeuvre us at every turn. She would sense exactly when we might want to put the lead on her, and speed off in the opposite direction. She could navigate from the middle of the vast city park to our house across a major six-lane highway, down busy Sydney streets through untold traffic lights and roundabouts, all in twenty minutes. How she managed it we never knew. She had not the slightest traffic sense, but somehow her guardian angel must have worked overtime for many years.

Eventually we realised that the problem of Ella was too big for even us, and we started to use several fabulous dog-walkers who became our saviours. When we heard that then Prime Minister Paul Keating and his wife had bought themselves a German Short-haired Pointer puppy, we wondered if we

should send them a letter warning them about the trouble they were in for. But we rather liked the idea of the prime minister's staff being enslaved to a GSP. For some reason it made us feel much better to know that even the prime minister and his wife could be conned.

Candida Baker

'A dog teaches a boy fidelity,
perseverance, and to turn around three
times before lying down.'

Robert Benchley

A Dog's Purpose?

I am a vet and I had been called to examine a ten-year-old Irish Wolfhound named Belker. The dog's owners, Ron, his wife Lisa, and their little boy Shane, were all very attached to Belker, and they were hoping for a miracle, even though they knew Belker was very sick.

I examined Belker and found he was dying of cancer. I told the family we couldn't do anything for him, and offered to perform the euthanasia procedure for the old dog in their home.

Ron and Lisa told me they thought it would be good for six-year-old Shane to observe the procedure. They felt as though Shane might learn something from the experience.

The next day, I felt the familiar catch in my throat as Belker's family surrounded him. Shane seemed so calm, petting the old dog for the last time,

that I wondered if he understood what was going on. Within a few minutes, Belker slipped peacefully away.

The little boy seemed to accept Belker's transition without any difficulty or confusion. We all sat together for a while, wondering aloud about the sad fact that animal lives are shorter than human lives.

Shane, who had been listening quietly, piped up: 'I know why,' he said.

Startled, we all turned to him. What came out of his mouth next stunned me. I'd never heard a more comforting explanation. It has changed the way I try to live.

He said, 'People are born so that they can learn how to live a good life—like loving everybody all the time and being nice, right? *Well, dogs already know how to do that, so they don't have to stay as long.*'

Anonymous

'The old dog barks without getting up,
I can remember when he was a pup.'

Robert Frost

Why Dogs Chase Cats

Once, long ago, Dog was married to Cat. They were happy together, but every night when Dog came home from work, Cat said she was too sick to make him dinner. Dog was patient with this talk for a while, but he soon got tired of making dinner for them both after a hard day's work. After all, Cat just stayed home all day long.

One day, Dog told Cat he was going to work, but instead he hid in the cupboard and watched Cat to see if she really was sick. As soon as Cat thought Dog had left, she started playing games with Kitten. They laughed and ran about. Cat wasn't the least bit sick. Dog jumped out of the cupboard. When Cat saw him, she stuck a marble in her cheek and told Dog she had a toothache. Dog got so mad at her he started chasing her around and around the house.

Dogs have been chasing Cats ever since.

S. E. Schlosser

Mistaken Identity

At one time, my brother and his family acquired an adult German Shepherd from the pound, and named her Roxie. I briefly met her on her first day at her new home, but about a week later I got a call for help. Roxie had somehow escaped from the backyard and was nowhere to be found.

The search party, comprising a few neighbours and friends, fanned out to walk the streets in search of the wayward animal. The search area to which I was allocated included a large park, and I was delighted when, on my final sweep, just as night was falling, I found her. I whipped off my belt, used it as a lead, took her back to my car and drove her to my brother's.

Triumphantly, I walked through the front door.

'I've found Roxie,' I proclaimed loudly.

'What do you mean, *you've* found her,' my brother said. '*I've* found her!'

There we were, in opposite corners of the family room, each with a German Shepherd on a lead. The dog I had grabbed was not Roxie, and I was lucky that she was a good-natured dog and didn't object to being handled by a stranger. Naturally, I returned her to the park, none the worse for wear!

David Faen

'There is no psychiatrist in the world like
a puppy licking your face.'

Bern Williams

Dog Therapists

Ever since I was young, dogs have followed me, not because I entice them, but because I just must have some aura that says I love them.

When I was about twelve years old, there was a Cocker Spaniel nearby. One day I stopped to pat her and say hello, and she immediately followed me home. I took her back, and back, and back, before her owners said, 'She just doesn't want to live here!' So my family kept her and loved her—her name was Jingles.

The same thing happened to me with two other dogs after that. I'm now sixty-two and have never been without a dog, and I wouldn't want to be.

We had a Mini Fox Terrier called Pixie, and when we moved near the beach she enjoyed coming for walks there with me, but when I went in to have a paddle, she would panic and pull gently on my ankles, trying to get

me to come out of the water. She must have known I can't swim and been worried about my safety!

When I retire in a couple of years I plan to do Pets as Therapy, which involves taking my dog to visit people in nursing homes or hospitals so they can enjoy a cuddle and feel the love . . . as I do. I have two Chihuahuas at present and I will soon get an Italian Greyhound as well. They are quiet and gentle and love people. So that's my plan: to share the love of dogs.

Janette Leaney

'Nobody can fully understand the meaning of love unless he's owned a dog. A dog can show you more honest affection with a flick of his tail than a man can gather through a lifetime of handshakes.'

Gene Hill

The Good Listener

Diggity-Dog taught me how to listen with my heart, how to listen with my eyes, and how to just sit there.

She could work with girls so traumatised that they no longer spoke. Girls hunched on couches in refuges smoking endless cigarettes. Digs would rest her chin on the edge of the couch and gaze up at them with a depth of understanding beyond anything I have ever seen.

Her domed, sleek head was made for stroking. Soothing, reassuring and warm, it never failed to help. Dig-It would tuck her ears down and sigh deeply. Her eyes would not waver as she stared intently at her human, as if straining to hear. She gave more comfort than any court order or social worker could. I just sat and learned from her, waiting for that cue to be let in.

Digs read distress and knew what to do about it in the same way that a sheep dog knows when to duck and weave, when to run forward and when to hold back so the sheep have room to move.

My old Diggity-Girl could read emotions just like that. She knew when to drop into a crouch and bark, skipping around the room doing cartwheels to get 'her girl' laughing. She would race, tail tucked in, across the room and behind the couch, then launch herself in a flying run to land back where she started, within easy reach for a pat, a wrestle or a hug.

Diggity-Dog could sense how close to go. Sometimes she would lie right across the room, pretending to sleep. I came to recognise that 'lying doggo' smile she had, different to her slack-jawed deep-sleeping pose. Diggity would lie curled up like a cat, and sometimes one eye would open a crack just to check out the room. Mostly, though, she operated by smell. She could sense people warming to her.

Even the hardest heart could not ignore the peace and calm she beamed into the room. Diggity's love accepted all the 'damaged goods' sitting around her. My dog turned the holding pen of misery that was the refuge into a home. The girls saw in her someone to talk to, to cuddle up with, to guard them from future harm. I watched Diggity unlock young girls who had been

in the welfare system most of their lives. I couldn't get them to talk. Some of the horrors they had seen went beyond explanation. But the simple presence of a dog made all the difference for them.

It wasn't sanitary taking a dog to work. Now that accountability and economic rationalism dominate every institution, it probably couldn't happen. And if it did, someone would no doubt complain. But I treated Digs for worms and fleas, and cleaned up her mess on the cement with disinfectant. It was worth the effort. She lit up that refuge more than the rest of us put together.

Diggity came to work with me at first because she too was a runaway, a damaged soul full of fear and hurt. I couldn't leave her at home and I couldn't afford to skip work to stay at home to care for her.

Who would have known how powerfully she would affect us all, and how her love would transform us?

Miss Diggity arrived in our yard from out of the bush one afternoon as a cringing bag of bones. She was starving and too afraid to approach us. She crouched with her head on her paws, watching us, hoping against hope, I think, that we might be a safe place for her. But we both worked shift-work and had no time for a dog, or so we thought.

The new life the powers-that-be had decided we would have with her started when I left out some food. She wouldn't approach unless we were at least twenty metres away. This gave her time to run if she needed to.

Gradually she allowed us to come closer. Eventually I could hold food in my hand and she would take it, gently, and very tentatively. Her beautiful brown eyes watched me, and her ears strained for any hint of danger.

All the time I talked quietly to her, saying things like, 'Hey little dog', 'Hey Hot Diggity', 'Who's the dog?' Eventually the name stuck: Diggity-Dog, or Diggity for short. (Years later I found out that Robin Davidson, the author of *Tracks*, had named her dog Diggity too.) The name fitted our dog and so our future youth counsellor got a name.

As the Tasmanian winter set in, she agreed to come inside to eat. She would lie on her sheepskin bed on the porch as long as the door was open for her to escape. Next, she moved in closer to the fire, and soon after that we had to push her back to reach the heat ourselves! Poor old Rags-to-Riches soon got used to the luxury of velvet cushions and soft couches. Diggity had found a home. After this there was no going back for any of us.

Diggity's breed was a mystery. She had the markings and bark of a German Shepherd, with a black saddle and short golden fur, but she was more like a

Basenji with her white markings and big bat-like ears and she was as slender and delicate as a Whippet. If I could design a dog breed, I wouldn't bother with a Labradoodle or any other sort of doodle. I would ask for another Diggity. She licked herself clean like a cat, and curled up on my lap, almost purring. But her bark was rough and loud like that of any good guard dog. Diggity could sense if there was a threat at the refuge door, barking with a fearsome bravado. Yet if a frightened soul was on the other side, she would whimper and scratch at the door, trying to get to them and offer them comfort.

The value of dogs is often measured by what they can do: lead the blind, detect drugs and contraband, search and rescue, or round up the herd. But it can be much simpler than that. Just the presence of a dog, loving unconditionally, listening and accepting, offering a wet nose and a warm pat, can work wonders. To dogs, offering love comes naturally. All we have to do is to look after them and let them be.

Marian Webb

'My little dog—a heartbeat at my feet.'

Edith Wharton

Please God, Make Me the Person My Dog Thinks I Am

I saw a bumper sticker one day which said: Please God, Make Me the Person My Dog Thinks I Am.

Dogs come into your life and enrich it, and when you are feeling down, they make you feel whole, loved and appreciated. You hold every dog that has been a part of your family in loving memory.

Years ago, we lived in a Sydney street that never managed to keep its sign because it was always stolen by teenagers. Bongalong Street was a lovely little cul-de-sac full of young families who all adopted our beautiful black Labrador cross (or as our vet categorised her, 'Could be many different breeds'). She was black with brindle points and had a white flash on her chest and paws. She was all Labrador by nature, and she loved to swim, play and eat. Her

name was Tina Turner because we had been to one of the singer's high-voltage concerts just before this personality-plus pup with the same larger-than-life attitude came into our care.

One of the joys of Tina's life was learning new tricks. We would open all the cupboard doors in the kitchen and ask her to close them, and Tina would do so using only her nose—as quick as a flash, as if she was always trying to beat her own personal best time.

She loved classical music. To help me through the housework, I would put on a CD, perhaps Vivaldi or Mozart, and soon I would find Tina Turner in the lounge room, her eyes closed, sitting right between the two speakers. If she could have spoken, I'm sure I would have heard her saying 'I just love Bach.' (We seemed to specialise in musical pets because our female cat Honky Tonk would enter the room like a whirling dervish the moment we put on a Rolling Stones CD. Honky loved rock and roll.)

We moved to Bongalong Street when Tina was a youthful six-year-old and she loved everyone in the street. Often there was a knock on the door and I would open it to find children pleading, 'Can Tina come to the park with us? Can Tina come for a walk with us? Mum says it's OK.' This was one very happy puppy. Because she just happened to be the only dog in the

street, she was shared with everybody. I didn't mind at all when one of our young mums took the liberty of borrowing her for the day when I was at work.

One day I came home from work to find Tina in our next-door neighbour's backyard, where she had been invited to a barbecue. Our neighbour's father was visiting from Adelaide and Tina was sitting beside the new visitor, looking up into his eyes with that loving look that only dogs can give, with her whole body pressed gently into his leg as he softly patted her face, head and ears. He was a fragile, gentle, regal-looking gentleman with an obvious love for animals.

For the next week our neighbour Sue continued inviting Tina over at her father-in-law's request, and the newfound friends would while away the hours together. Sue's young son also joined the pair from time to time, and I felt Sue was happy for Tina to provide a little company and entertainment while she did her chores.

One day when I came home from work and Tina was, as usual, next door still glued to her friend, I went over, exchanged greetings with Sue and the others, chatted about our day and called Tina in. She did not come. I called her again, and she did not budge. I was stunned. This was the first time in

231

her life that she had been disobedient. Sue's father-in-law said, 'That's OK, she can stay with me for a while,' and I returned home, feeling quite hurt.

When I finally managed to get Tina home, she would not settle down. I tried to soothe her, wondering what was going on and why she was feeling so restless.

At 3 a.m., I was woken by a long blood-curdling howl.

I put on my dressing gown and went out the back door to find Tina on our neighbour's back doorstep, the closest she could get to her friend's room. I knew it was Tina's howl but I had never heard her use it in such a way. I called her in, feeling quite embarrassed, feeling that she might have woken up other people in the street, and again Tina was reluctant to come with me.

I managed to get back to sleep but was suddenly woken again with the lights of an ambulance flashing through my bedroom window. I was worried and tried to convince myself that everything was OK. Tina was awake in her bed, which was beside mine, so I reached down and stroked her back to sleep.

On returning home from work that day, I saw that Sue, her husband, neighbours and friends were all gathered in Sue's backyard. Sue's eyes were red, and her husband had his head in his hands, and Tina was beside him. Sue and I embraced while she told me that when she had been woken up by

Tina's howl, she had got up, had a drink of water, and looked in on her father-in-law to find that just at that moment he had passed quietly away in his sleep.

I believe that Tina Turner wanted to be beside her friend to the end, and I believe she needed to herald his passing.

The next morning we did Tina's favourite thing—I took her to the beach for a swim. When we got home all the children were clamouring to help me hose the salt water from her coat. Children were squealing and running around as we hosed each other, and Tina was jumping up and down playing, with tail wagging.

All was well again in Bongalong Street. But we were all perhaps a little older and a little wiser.

Maxine Prain

'I wonder what goes through his mind when he sees us peeing in his water bowl.'

Penny Ward Moser

Ella the Evil

It's a humid, dusty Sunday in Centennial Park and I'm being poked in the chest by a man who is shouting at me, so furious that tears are spurting from his eyes like bullets.

'Your evil dog is giving my wife post-natal depression!' he yells.

The man is Indian, I think, and so agitated that he is producing projectile tears. His lips are trembling. My small son grips my hand in fright as the man keeps prodding me. As I try to dodge his poking finger, picnickers watch us with interest. Everyone's attention has been caught by the man's shouts, by women's wailing and arm-waving and the flurry of saris.

If only I could turn the clock back ten minutes. Way back then, dog, boy and father were lolling in the farthest, shadiest, dog-permitted reaches of the park. And then on the faintest of summer breezes, across the competing smells of the bumper-to-bumper traffic on the park's ring road and the pungent

horse-riding track and five or six hundred metres of swampy lake and recently mown grass, to her alone of all the dogs and people here, wafted the aroma of distant curry.

And she was off.

Now Ella's mouth is greasy with dhal and poppadom crumbs. She darts around us, swerving from my lunging hands. Her body surges and twists with the thrill of the hubbub. She's charged by the family's hysteria, transformed into something white-eyed and crazy and rippling like a nervy racehorse. It's as if all her springy litheness has been bred into her just for this perfect moment of chaos.

No one comprehends my apologetic dog logic. I'm very sorry. Please relax. Ignore her. Believe me, your screaming and jumping is just exciting her. She doesn't bite. She's just playful.

I feel total, 100 per cent sympathy. The Indian woman has a young baby. My dog is wrecking a peaceful family gathering.

Let's be honest, there's also a small but growing annoyance at the finger jabs and wild theatrics. But I feel so guilty I can't yell at them, Get a grip! (Would I be so passive if there were wurst-munching Germans, say, picnicking in liederhosen, prodding me?)

Anyway, no one's listening to me. Not the Indians, certainly not Ella. It's like shouting in a dream. I'm standing there sweating and bewildered, in a familiar agitated trance. The situation is now far beyond dog and people and a disrupted picnic and differing East/West attitudes to pets. It's deep, dark, collective-unconscious stuff now, genetics and myth and the shadow of the hawk.

Of course, Ella's to blame again, once more an agent of turbulence and disarray.

She might look like a dog—a handsome, liver-coloured, spayed, German Short-haired Pointer—but she's actually a sort of anti-dog. She doesn't fetch or come, or even favour a particular person. While she probably prefers our family to strangers, she'll betray us for anyone with a bag of chips or a ham sandwich.

Perhaps, as the Indian man insists, she is 'evil'. Dogs are a symbol of evil in some mythologies. But her drives are more simple, and complex than that. She's ruled by her nose, by her breed's Bloodhound genes. To smell is potentially to eat, and she lives to eat. She'll eat anything that can't be strictly classified as mineral. And at the moment her whole reason for existence hinges on those poppadoms and curries.

Despite my entreaties, the Indian family won't calm down. They won't stop shouting and jumping about. The woman, who has now begun to howl, holds her baby horizontally above her head, as if from a tiger or a wolf. The baby is beginning to scream, and an older, plumper, moaning woman, presumably the grandmother, is trying to take it from its mother.

Grandmother has climbed on to a drinks cooler. She's wobbling on the cooler's lid and yelling for the mother to pass the baby over her head to her for safety in case Ella devours them both. But the mother refuses to give it up, so they wrestle over it for a while, wailing and keening, while Ella barks and leaps joyfully at them.

I'm aware of the muttering and movement of the other picnickers. Egged on by their wives, men in their weekend shorts and baseball caps get up from their picnics, some holding cricket bats and sticks, and start towards us. They're saying, 'What's going on here?'

Denied the baby, the grandmother has come to the decision to bravely sacrifice herself. She clambers down from the drinks cooler, rushes at the dog in a flurry of silks, and starts pelting her with cutlery and food containers. This really sets Ella barking with excitement. She can't believe the high standard of entertainment, especially with spicy food thrown in.

Meanwhile, the younger woman is standing on her toes and holding the baby so high above her head that her sari exposes more than her midriff. The shouts of her husband become shriller and the baby cries louder.

And, fighting against the sensation that I'm actually in a dream, I finally break the stalemate. Abruptly I break and run.

I'm turning my back on these people who hate me and my dog, on the whole picnic-ground fracas. I'm also performing the only known successful method of getting Ella to come.

I grab up my son, run across the park to my car, jump in and speed away. I brake sharply after about fifty metres, sound the horn, then speed off once more, again beeping the horn. I stop and start a few more times. By now the whole picnic ground is standing and pointing at our jerky, honking progress.

And then I slow down as Ella, disconcerted that her fed-up 'master' has finally decided to leave her forever, makes the decision to forgo the poppadoms. She knifes across the park like a greyhound, through the crowds of cursing picnickers and jumps into the moving getaway car.

Robert Drewe

'Dogs are better than human beings,
because they know but do not tell.'

Emily Dickinson

Jester

My husband and I adopted Jester almost four years ago. We had been married for less than a month, we had just moved to Mississippi, and we decided that our yard would look a lot better if it had a dog in it.

We started our search, first at local shelters and then using the internet. We had seen a lot of dogs, but none had really grabbed at us. Finally, I came across a profile that broke my heart.

The little black Labrador puppy shown in the ad was rescued from an owner in Alabama, where he and his sister were suffering from neglect and left in a backyard by themselves. His sister was a yellow Labrador, and she was adopted out quickly, but this puppy had not been taken. His little face was so sweet and so pathetic. I thought, how could someone just forget about it?

I called my husband in and showed him the picture.

We drove out there the next Sunday, just expecting to look at him and then go home to think about it and make our decision. That plan went out the window when we pulled up and the happiest-looking puppy I've ever seen got out of the car.

He wasn't very big then, only twelve kilograms, but his exuberance was larger than life. He ran to us, as if he knew he was supposed to be ours. My husband picked him up, looked at the foster family and asked who he could make the cheque out to.

We named him Jester because he makes us laugh. He has grown up a lot since then. He is four years old, weighs about thirty-five kilos and he is the best dog my husband and I have ever had.

He makes life so much fun. We take him hiking and backpacking—and he's big enough to carry his own pack. His favourite activity is whatever he's doing at the time: playing fetch, playing with his toys, playing with other dogs, eating. He has moved with us to several different states, and he keeps me company when my husband is deployed. He is, quite simply, the best dog in the world.

Becky Meier

'When she looked into the eyes of that creature, she knowed what it was. Sure enough the spirit of her man was beside her now in the shape of a dog. And if there's anything that can give meanness a run for its money, it's a Dog Ghost protecting someone it loves.'

Narrator, *Hannah and the Dog Ghost*

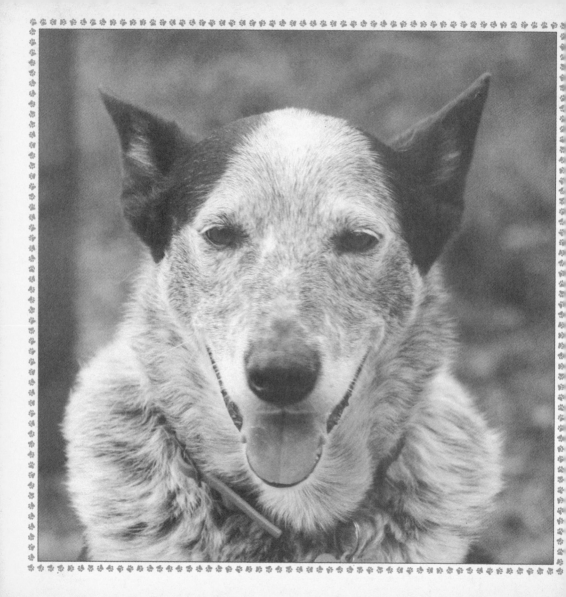

Big Heart

We offer our heartfelt thanks for your love and support during our beloved Big Heart's transition from this life.

Big Heart died at 1.12 p.m. on Friday, the 12th of July. He gazed deeply into Cory's eyes as he died. He was completely peaceful; he simply closed his eyes. Upon his death, I whispered in his ear, 'Big Heart, your attention is now going deep within your body. In a short while, you will see a bright light. It is important to follow that light. Don't cling to what you knew in this lifetime; to Cory or to me, just let go into the Light. Go to the Light. Go to God.'

Soon after, Big Heart's body was moved to a room that had been prepared for the vigil. He was placed on a mattress with yellow flannel sheets on it and a yellow pillow. Yellow irises were beside him and candles were ready to be lit. I covered him with another sheet and placed flowers from our garden on top of him.

The vigil then began. Cory and I stayed with him for four hours, loving him and letting him go at the same time. In some moments, we felt a lot of sorrow and loss, but we tried to keep releasing it so that our attention was free to help Big Heart.

We focused on staying connected to him psychically so we could determine if he was struggling during the transition. At a few points, he clearly did struggle. He became confused or weakened and his attention wandered. At each of these points, Cory spoke to him clearly and strongly. 'You are a strong and noble being, Big Heart. You do not have to let anything overwhelm you. Keep using your strength to follow the Light.'

Within moments of Cory's speaking to him in this way, we could feel a shift and we knew he had found his way through that particular distraction or struggle.

At 5 p.m., his first visitor arrived. She brought her favourite prayer and recited it for Big Heart. She placed her gift of flowers beside him and sat with him for two hours.

Soon another friend arrived. She sat next to Big Heart and sang a song that she told me she had been singing to him throughout the day. Two boys

from the neighbourhood who loved Big Heart and used to take him for walks arrived. They sat quietly, obviously moved, and then joined in the chant:

Good-bye Big Heart, good-bye Big Heart.
Go where you want to go,
Be where you want to be.
Our love goes with you.

In the middle of this, Paddy, our younger dog, arrived home. He had spent the day with a friend who loved Big Heart deeply. She gave me a card and a beautiful purple candle and told me how Big Heart had touched her life in a way that no other dog had. I resonated with her words, feeling how much Big Heart's love had healed me.

The two young boys then focused on Paddy. We had asked them to spend the night in another room with him so that we could stay with Big Heart all through the night. Once Paddy was asleep, though, the boys came right back into the vigil room and sat quietly next to Big Heart again.

Around midnight, Cory and I resumed our time with Big Heart by ourselves. By this time, the room was filled with flowers, cards and candles that people

had brought for him. And the room felt so, so happy! We helped Big Heart through one more difficult point at about 1.30 a.m., and then we sensed that we could go to sleep for a few hours.

Many other people were with us in spirit on the day of Big Heart's death, and all these people sent love and energy to us during the day, and we received it fully. Despite the fact that we had not slept much the night before and were anticipating the vigil, we did not feel tired. We knew this could only be because of the love and support our friends were sending our way.

We woke up very early in the morning on Saturday the 13th, and connected with Big Heart again. It was clear that he had almost completed the transition. We could not feel him present with us any more and we could feel him sublimed in what is Greater. At 7.41 a.m. in the morning of 13 July, Big Heart completed his transition from this life. We felt he was Home.

People continued to sit with his body through the morning. At 1:30 p.m., I draped his body in a clean sheet, put fresh flowers on top and prepared for his body's departure from our home.

Two and a half days have passed since Big Heart died. Cory and I feel grateful to have participated so fully in his death and transition. We feel such

love and respect for this being who taught us so much about surrender through his life and now through his death.

We also feel grateful to have discovered—for real—that love simply does not die.

Thank you all. We could not have done it without you!

Cory and Maryanne Sea

Do I Go Home Today?

My family brought me home cradled in their arms.

They cuddled me and smiled at me and said I was full of charm.

They played with me and laughed with me and showered me with toys.

I sure do love my family, especially the girls and boys.

The children loved to feed me, they gave me special treats.

They even let me sleep with them, all snuggled in the sheets.

I used to go for long walks, often several times a day.

They even fought to hold the leash, I'm very proud to say.

These are the things I'll not forget—a cherished memory.

I now live in the shelter—without my family.

They used to laugh and praise me when I played with that old shoe.

But I didn't know the difference 'tween the old ones and the new.

The kids and I would grab a rag, for hours we would tug.

So I thought I did the right thing when I chewed the bedroom rug.

They said that I was naughty, and would have to live outside.

This I did not understand, although I tried and tried.

One by one the long walks stopped; they said they hadn't time.

I wish that I could change things, I wish I knew my crime.

My life became so lonely in the backyard on a chain.

I barked and barked the whole day long to stop going insane.

So they brought me to the shelter but they wouldn't explain why.

They said I caused an allergy, then each kissed me good-bye.

If I'd only had some classes as a tiny little pup,

I'd be easier to handle when I was all grown up.

'You only have one day left,' I heard the worker say.

Does she mean I have a second chance? *Do I go home today?*

Sandi Thompson

Saved by a Psychic Dog

A number of years ago, I was living in a house that had a small porch in front of the main door. The porch had a screen door that I usually kept locked. When someone came to the door, they would ring the doorbell and I would go out on the porch, greet them, and unlock the screen door to let them in. My smooth Collie-mix Nenkin would usually accompany me out on the porch. She loved people and loved to say hello to anyone coming in.

One summer evening, the doorbell rang and I went out onto the porch. Standing in front of the screen door was a clean-cut man in his thirties. He said that his car had broken down and asked if he come inside to use our phone. Not many people had mobiles then, so his request seemed reasonable.

As I was about to unlock the screen door, Nenkin appeared at my side. She took one look at the man and her hackles rose. She bared her teeth and

barked furiously. I couldn't believe that this was the same dog who lavished love on everyone coming into the house.

I grabbed her collar to keep her from lunging at the screen door, and told the man I was sorry, I couldn't let him in because there was something wrong with my dog. He was clearly frightened by Nenkin's barking and went away quickly.

The next day I read about this man in our local newspaper. It seems he went to another house a couple of blocks away, knocked on the door with the same story, and was let in by a kind elderly couple. He overpowered them, tied them to chairs, robbed the house and stole their car. He was stopped for speeding some 240 kilometres away, and because his name did not match the car's registration, the police became suspicious and detained him. They called our local police to check on the car's registered owners and when there was no response, an officer went to the couple's house, found them tied up and freed them. If things had not happened as they did, the couple might well have died.

So my dog sensed that the man was not a good person, and saved us.

Was she psychic? Maybe.

Rupert Sheldrake, in his 1999 book *Dogs That Know When Their Owners are Coming Home, and Other Unexplained Powers of Animals*, documents a number of

unexplained abilities that seem to suggest a psychic nature. One of his chapters deals with dogs and cats psychically picking up the intentions of the humans around them.

But there might be an alternative explanation.

Recent research shows that dogs are very attentive to human body language and to subtle cues we humans don't even notice. Perhaps there was something about the man's posture that gave him away. Or perhaps Nenkin smelled a fear emanating from the man, or even anger. I never saw her behave like that again to anyone else. But whatever it was, I was very grateful to her. She saved the day.

Anonymous

Silent Communication

My wife and I were taking a walk around our neighbourhood one day when we came across an unnerving sight. Two youngsters were hovering over an apparently injured dog and they asked us if would be able to help them. The Golden Retriever was lying on his side but had no apparent injury. He was able to raise his head and, like most Retrievers, he was licking anyone who tried to pet him.

But something was wrong, because he wasn't even trying to get up.

Suddenly a passing car screeched to a halt, and a woman jumped out. 'Sampson, Sampson,' she shouted as she rushed over to the dog. 'I'm so happy I've found you.'

And at that moment, the dog leaped to his feet, almost beaming with joy. I explained to the woman that Sampson had refused to get up and that we

didn't know what was wrong with him. She told us that Sampson had run off when the gardener had accidentally left her back gate open.

She knew that when a dog was lost it had a tendency to run and run until it was exhausted, and the dog could end up tens of miles away from home. 'So,' she said, 'I kept shouting in my mind "Lie down, lie down," hoping against hope that I could silently communicate with him.'

I would have been sceptical had I not seen it happen with my own eyes. It was the most amazing thing I've ever witnessed.

P. Brown

Dinah Dog

After Minnie, the Poodle of my childhood, was put down when I was thirteen, my mother decided there would be no more dogs. Horses, cats, guinea pigs, rabbits and goldfish were quite enough, she said.

However, my father had other ideas.

At the time he was playing Launce in *Two Gentlemen of Verona*, and of course he had need of a 'cur':

> Think Crab, my dog, be the sourest-natured
> Dog that lives: my mother weeping, my father
> Wailing, my sister crying, our maid howling, our cat
> Wringing her hands, and all our house in a great
> Perplexity, yet did not this cruel-hearted cur shed

One tear: he is a stone, a very pebble stone, and

Has no more pity in him than a dog.

Dad was duly sent by the director to the anti-vivisection society in London to choose a dog. He came back with a fabulous mutta girl-dog (we've never liked the word 'bitch' in our very female family), tan, black and brown, of medium height and build, with the biggest brown eyes and a perpetually worried expression.

She had been rounded up raiding rubbish bins, and having been rescued from the pound by my dad, she attached herself to him with literally dog-like devotion. She adored him.

She also showed a flair for acting, knowing exactly when to turn away from him, or walk across the stage, or sit and scratch her fleas, or gaze mournfully at the audience, getting—as my father said ruefully—rather more laughs than he did.

But at the end of the run nobody knew what to do with Dinah, as she had been christened. (I never did think to ask why.) If she went back to the society, it was almost inevitable that she would be put down—there were far

too many homeless mongrel strays in London for Dinah to be special, even if she had been on stage.

So Dad, who by then was living away in London during the week, brought Dinah home to us in Oxfordshire.

I loved her immediately, with all my heart. I had visions of her coming riding with me, keeping me company on my bicycle, and filling the space in my heart and soul left by Minnie's death. But at first, life with Dinah was disappointing, to say the least.

To begin with, she missed Dad desperately, pining day and night. She followed us about, but with no real enthusiasm, seemingly worried by the large space of our garden, let alone the hundreds of acres which surrounded us. She was clearly unwilling to trust us, and I began to think that the idea of a new dog as a constant companion was just a fantasy.

A few weekends after she came to live with us, my best friend Sally and I took her for a walk up the lane. She followed politely and quietly as usual and we turned into one of the large fields on the estate which was 'resting' from animals at the time. We sat together in the middle of the field, and Dinah sat beside us, the picture of indifference.

Sally was my companion on many childhood and teenage adventures. She and I talked about Dinah and wondered how a dog could be so traumatised that it didn't even seem to recognise the idea of space in which to roam free.

As we chatted, Dinah got up and moved a bit away from us, sniffing the grass and pottering about in a genteel fashion. She made her way back to us, and we patted her. Then she moved away again, a bit further this time—and then suddenly, as if someone had shot her with a dart, she ran forward about fifty metres, stopped, turned and looked at us, and ran towards us. We laughed and lay on our backs, and she leapt on us and licked us and ran again, further than before.

Somewhere in the dim and distant past, Dinah may have had a Greyhound ancestor, because she had a long, deep chest for a medium-sized dog, and powerful back legs when she ran. Now, as if some genetic memory-button had been pressed, she began to run and run and run, occasionally coming back to throw herself on top of us in absolute joyous abandonment.

Her happiness was infectious, and Sally and I began to run as well, playing at being dogs, barking and leaping and jumping. If anybody had seen us, they would have thought we were quite mad—a dog and two girls leaping and twirling around and around and around.

Finally, we all collapsed on the ground. Sally and I lay on our backs looking up at the clouds, and Dinah stretched out in the sunshine with a smile on her face.

It was a transformed dog who followed me home that day, and from then on she was the fantasy friend. She rode with me, and walked with me, and slept with me, and was the confidante in all my troubles. Of course, she belonged to my sisters as well, but as far as I was concerned she was my best friend.

She was a dog with some curious quirks. She pretended to be scared of the two Siamese cats, who both ganged up on her in an 'I am Siamese, if you please' kind of way. She once jumped out of the second-floor bedroom window to get away from them, to the surprise of my mother who was gardening right by the spot where Dinah landed in the rosebush. But at night, when no one was watching, she and the cats would curl up together. If you got up early enough in the morning you would catch the ceasefire, but once the household was awake, the battle lines were redrawn. Dinah never lost her penchant for rubbish bins, despite her regular meals, delighting in knocking them over and diving into the smelly treasure. She was also, I fear, somewhat racist, and when we moved back to London temporarily she caused us no little embarrassment by barking at anyone who didn't fit in with her racial policies. But apart from these odd bits of behaviour, she was an exemplary dog.

When I began to travel as a teenager, Dinah hated it. She always seemed to sense when a farewell was in the air, sleeping on my bed the night before, and looking at me with reproachful eyes. At twenty-two I emigrated to Australia. A year later I came back for a holiday and was leaving again, and Dinah knew only too well. It was not old age that kept her on my sister's bed that morning. She would not even look at me, turning her eyes to the wall and refusing to say good-bye.

By the time I came back, three years later, she was living at my father's house in London because my mother's alcoholism meant she could not look after Dinah properly, and by then Dinah was an old dog. She seemed not even to recognise me, which broke my heart, but I knew that she was being well cared for. She was back with Dad, her first rescuer. She was being walked every day with his younger dog in the local park, and being treated with the best of care.

When her time came, the vet allowed my father and stepmother to send her off at home with a pill buried in a chocolate, which seems very civilised to me. She slipped away to the endless fields of heaven, where I hope she still runs and runs.

Candida Baker

Comfort from a Dog

I'd just got back from my Valkyrie act, taking all five dogs to the vet for their heartworm check. I had asked for the first appointment of the day, to avoid the craziness of the afternoon appointments.

When I walked in with the dogs, I was surprised to see a knot of people in the back room. The door was open. The vet still had her overcoat on and I could see that they were performing CPR on a large Rottweiler. An assistant came out and apologised for the fact that I'd have to wait.

Do what you have to do, I said. I can wait all day.

They left the door open. One of my dogs, Beckett, stood and watched it all intently, never taking his eyes off the back room. Finally, a guy came out and told me what was going on. He'd been jogging through the parking lot when he heard a man he had just passed cry out, 'Oh, no, Charlie.' And then, 'Help, I think he's dead.'

The man who owned the dog had called the clinic on his car phone shortly before to tell them he was bringing in Charliedog. Charlie had been vomiting the night before, and in the morning. He was unable to stand and appeared to be very sick. The man loaded him in the car, calling the clinic on the way there. He got there as the centre was opening up, and left Charlie in the car until the vet arrived, since Charlie weighed 68 kilograms and he needed a gurney to get Charlie out of the car and into the surgery.

While the vet got ready, the guy went back out to the car to check on the dog. That's when he found Charlie apparently dead, cried out, and the jogger turned back to help him.

When they got Charlie inside, moments before I'd arrived with my gang, they found a faint heartbeat and attempted to revive him. The jogger came out to talk to me just as they were giving up, after about twenty minutes of CPR.

Meanwhile, Beckett, one of my rescue dogs, didn't take his eyes off the goings-on in the back room. The rest of the gang were lying down or milling around, but Beckett was like a statue watching everything. He watched as they rolled the gurney out to us, and out the door. He watched as they loaded Charlie's body back into the car. He watched as the people came back inside.

He watched as the owner sat down in the chair next to me and put his head in his hands and sobbed.

Beckett watched. And watched. After about a minute, Beckett quietly moved around the rest of my gang, walked over to the man, and very slowly slid his head under his hands and hid his face in the man's lap. Then he just stood there. The vet and the nurse and I looked at each other and all lost it at the same moment.

The man lifted his head and looked down at Beckett, who had his face hidden against the man's belly, and was still standing there as still as a statue. He spread his hands and sat looking down at the back of Beckett's neck, somewhat bewildered, and then he looked up at us, with his hands still spread, as if to say, 'What's this?'

Whereupon Beckett looked up the man, and kissed his face. The man threw his arms around Beckett and hid his face against Beckett's neck and cried for about another minute. Then he stood up, wiped his arm over his face, gave us a little sad smile, and walked out. No one said anything. Beckett walked over to the door and watched him leave. Then he turned back to me, licked my face once, and lay down on the floor next to my chair.

The vet and I just looked at one another, and then began to weigh the dogs and get on with things. None of us mentioned what had just occurred

until later, when the vet finished drawing Beckett's blood. She was kneeling next to him on the floor, and when she finished, she put her arm around him, looked up at me, and said, 'What a wonderful dog—he just took care of all of us, didn't he?'

'Yes,' I said. 'He's something special. I think I'll keep him.'

And I think I will.

They still don't know what Charlie died from. I feel very sad that such a beautiful young dog died so suddenly and that nothing could be done to save him. Maybe from his spot in heaven, Charlie saw the small act of kindness that Beckett offered to his owner, and when Beckett makes his own passage to the Bridge, there will be a big, happy, beautiful Rottie there waiting to greet him.

A dog rescuer

9/11: The Path to Safety

From *Guide Dog News*, 2001

Our country is in mourning over the events that have happened recently. Our hearts have been torn by the knowledge that innocent people, caring people, are now gone. We like to believe that all people are good, that civilization is strong, and that the world is a safe place to live. In the midst of such tragedy, it's inspirational stories like the following that help outweigh the bad.

Michael Hingson was on the seventy-eighth floor of the World Trade Center in New York on that fateful Tuesday morning when the building was struck by a plane under the control of a terrorist fanatic.

His yellow Lab guide, Roselle, was sleeping peacefully under his desk, and the two had been going about their daily routines. Michael is the district sales

manager for the computer company Quantum ATL and had been hosting a meeting of sales representatives.

'I heard a loud noise like a bump and then a lot of shaking. It was worse than any earthquake I've ever experienced,' he said. (Michael grew up in Palmdale, Calif., and had experienced the Northridge earthquake that struck the state in '94, among others. He now lives with his wife Karen in Westfield, NJ.)

'The building started swaying, and the air was filled with smoke, fire, paper and the smell of kerosene,' he said. The plane had struck fifteen floors above him. He knew something serious had happened, and his first thought was to call his wife and then make sure everyone in the office was evacuated safely. His wife would not hear from him again until he emerged from the building hours later.

'We knew the emergency exit procedures and people did a very good job of following them,' Michael said. Roselle led him through the dishevelled office and to the stairwell to begin the long descent, sometimes guiding, sometimes following behind him when things were tight.

Although they didn't feel anything, Michael estimated that the second plane had struck the other tower when they were somewhere around the fiftieth

floor. 'By the time we reached the bottom, it had become very hard to breathe,' he said. 'We were both very hot and tired. Roselle was panting and wanted to drink the water that was pooled on the floor.'

They continued walking away from the building. They were about two blocks away when Tower 2 began to collapse. 'It sounded like a metal and concrete waterfall,' he said. 'We started running for the subway.' Roselle remained focused on her work, and he kept his commands simple. When they emerged and were making their way from the scene, Tower 1 toppled, showering them with ash and debris. Roselle guided him to the home of a friend in mid-Manhattan, where they stayed until the trains were running again. He finally returned home to his worried wife at 7 p.m.

When we spoke with Michael on the day after the tragedy, he said that they were both feeling stiff and sore, but were otherwise fine. Roselle had been sleeping for a lot of the time, but would get up occasionally and play with Michael's retired yellow Lab guide, Linnie. Michael said, 'For me the saddest part was talking to the firemen as they were coming up the stairs—that's what I'll always remember most.'

Name withheld

'To sit with a dog on a hillside on a glorious afternoon is to be back in Eden, where doing nothing was not boring—it was peace.'

Milan Kundera

Corky Makes the Transfer

On 30 December 2000, just before 10 p.m., we returned from the emergency pet hospital where we had taken our dog Corky after he had collapsed in our kitchen. The vet said that Corky had a nervous-system disorder, that his rear left leg was paralysed and, at his age of sixteen, it would not get better. It would be in his best interest, the vet said, if we put him to sleep. With great sadness, we agreed to do this. We were told that they would administer an injection within 15 to 20 minutes and that he would not suffer and we made the decision to say our good-byes and go home.

When we returned home, I turned on my computer to search for a particular photo of Corky. I did the search but couldn't remember the name I had given the photo. When typing in the search box, I thought I'd typed in 'Corky' but I actually typed in 'Corky 3', so I backspaced, deleted the '3' and proceeded with the search.

As soon as the search provided me with a list of documents with 'Corky' in their name, I heard an alert message saying: 'Transfer of information complete.' Normally I don't take any notice of alert messages, but I had never heard a spoken message before and I was not in the process of transferring any information. I was not—get this—even connected to the internet. In addition, I did not have 'sound manager' or 'speech' extensions turned on in my system folder. To this day I have no idea what caused the message. It also seemed odd to me that the voice coming from the computer was very deep, yet quite clear, most unlike the 'voices' that are installed on my computer. Since then I have repeated what I did to see if this 'alert message' would come on, but I have never been able to generate such an alert message again. By the way, the photo that I was looking for was actually titled 'Corky3.'

My partner said it was probably a 'God thing'. As Corky had been scheduled to be put to sleep at almost the exact time I did the search, he said, perhaps the statement 'Transfer of information complete' was an assurance that Corky was already in heaven!

It sounds a bit crazy and I may be interpreting something logical simply so it eases my pain and sadness at losing Corky, but I can't get out of my

mind the strange voice. It came through so crystal clear and so unlike computer generated 'voices' which often sound mechanical. The sound I heard seemed to be a real human voice and I like to think it was.

Barbara L.

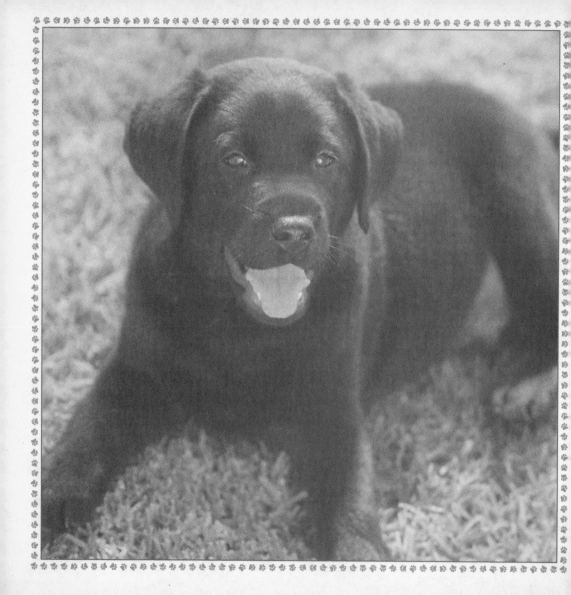

A Hero Dog

Recently, a family from the tropical north of Queensland decided they wanted a pet who could also be a guard dog. At their local pound, they were shown many dogs, but none seemed quite for them.

They were about to leave when they noticed a dog they had not been offered. When they asked why, the pound official said that he had just been admitted. His previous owners had starved him and regularly beaten him. He was in an appalling condition.

The family had a quick conference and decided that this was the dog they wanted, but they would wait until the RSPCA decided he was fit to be adopted. Some weeks later they proudly picked up their new pet, which happened to be a Doberman Pinscher.

He seemed to settle in well, and to understand that his bad days were over. Only four days after he arrived in his new home, the mum was looking out

of her kitchen window while she was washing up and in the backyard was an idyllic scene.

Her fourteen-month-old baby was crawling on the lawn as the dog lay blissfully enjoying the sun. Suddenly, the Doberman rose, ran to the child, picked her up by her nappy, and threw her across the yard. The mother, in shock and horror, raced out to save her baby from what she naturally thought was a dog attack.

As she ran to the baby, she noticed that the dog had lost all interest, but instead he seemed to be staring closely at part of the lawn. Going over to chastise the dog, she was stunned to see him doing battle with a venomous Taipan snake. Only then did it dawn on her that far from attacking the baby, the dog had saved her baby's life!

The dog himself had been badly bitten, and he was rushed to the nearest vet to see if his life could be saved. After forty-eight hours of continuous treatment, one very wobbly dog was released back to his owners. The vet refused to accept any fee, saying that this dog, who had known such an unhappy life, had proved himself a hero, and cost did not come into the effort to save his life.

Needless to say, the Doberman will never find himself abandoned again. He is truly there to stay!

Anonymous

My Golden Retriever—PK

He lived for fifteen years and in many ways was my sixth child. Over the last few years he became tired as old men do, and lay, like a breathing door mat, in the centre of our kitchen. He watched us come and go and occasionally smiled when dinners became raucous and filled with hysterical laughter. For three years he sat under my desk as I wrote my first book and sometimes rested my feet on his big, soft, furry tummy.

One night after everyone had gone to bed, I was turning out the lights when I realised he just couldn't get up any more. I brought down a towel and placed it under him and then went upstairs to bed. I knew it was probably going to be his last night so instead of going to bed I slipped off my blankets and dragged down my pillow and curled up next to him on the kitchen floor. And we talked. I told him that for fifteen years he had been the most loyal

and beautiful dog possible. I told him that I would miss his big brown eyes watching us all and I would miss his smile when anything funny happened.

In the morning my husband came into the kitchen and found PK and me sleeping. PK couldn't stand up and was upset that he was wet, so I changed the towel and made sure he was clean and fresh. We woke all the children and phoned our eldest, who was living overseas. She stayed on the speaker phone for the next hour. It was time to say our farewells to our beloved dog. Each child told PK how much he or she loved him and told him a story they remembered about his life. We remembered how he had run away every day when he was younger, and no matter how we'd built and rebuilt the fence it could never hold him in. Finally we all sat down with him and told him we could not continue this way and if he wanted to stay he would have to pull his socks up. He did. He stopped running away after that.

I called the vet and told him that PK was ready to pass over and might need a little help. He came straight away. As the vet filled the syringe we asked PK if he was really ready. Slowly turning his head, he looked at each one of us, gazing right into our eyes, and then he nodded.

We placed our hands on PK, some on his head, others on his shoulders and back and tummy. He put his head down and was still. The vet sat on

the floor with us and told us what to expect. Then he took PK's paw. PK turned and silently smiled at each of us, and when he had finished he gently put his head down and died.

The boys, including my husband, dug a hole in the garden and my daughter and I watched over PK's body. We buried him under our huge mandarin tree. It was a privilege to know PK. We were all better people for having known him.

Sharon Snir

Jack—The Dog of my Dreams

One of my most special memories is the time when I got the dog of my dreams. Jack is a Flat-coat Retriever and terribly handsome. We got him when he was seven weeks old and not much bigger than a cushion.

When he was young we used to feed him soggy cereal. I remember cradling him in my arms like a baby on the way back home. He grew up bouncy and fun, as well as cute and nice to snuggle with at times.

Now I kiss him good morning and goodnight, and I hope our friendship will develop even more.

One of the funniest memories I have of him is of when he was just about big enough to jump up and reach the kitchen sideboard without much difficulty.

Daddy had made two hot loaves of bread and had set them out to cool. When we got back from church, both loaves were missing. You should have seen the look on Daddy's face!

One of the cutest memories I have of him was when he was still very small. From the time he was a puppy he loved the garden and country walks, so every time he fancied taking a stroll he would climb through the cat flap and scrape at the door like a wild thing!

When Jack grew bigger, instead of going through the cat flap, he would open the door himself. He would stand on his hind legs and put his paws on the handle. He always does it to the back door. In winter it lets in freezing-cold draughts. I only wish he could close doors as well. It's really annoying when you have to keep on getting up from your seat and closing the back door. Now that he's learned to open doors, when he hears the doorbell ring he's always the first to answer it!

Rebecca Pearson, age ten

Guilty as Charged

It seems impossible to imagine now, but I did not want my new guide dog Rosi when she first came to us. Oh, I needed her all right. My old guide dog had died suddenly and that meant the equally abrupt removal of independence. Long-cane training never leaves you but you get out of practice, and a cane is rarely the preferred option for most guide-dog owners. Knowing how lucky I was to be offered a replacement dog just weeks after Dori died should have helped, but it didn't. Which brings us back to Rosi, real name Roselle. I needed her, but the only dog I wanted was the one that had left me.

It was late autumn when Rosi arrived on a cheerless, overcast Friday morning in June. It is impossible to say which of us was more nervous. She was wary and subdued after being shuttled between various carers since arriving from New Zealand a few weeks earlier. I was just plain terrified, or as terrified as you can be when feeling emotionally locked down and frozen.

Still, we watched with interest Rosi's first tentative games with Allie, our German Shepherd, and her careful testing of boundaries, as if she was checking to see if she dared to be herself. We were to learn that her puppyish philosophy is 'Life's a game and everything's a toy', but that did not become evident immediately.

A new dog's first bark is always a thrill, and Rosi's sounded loud and clear the next day when a friend arrived at the door sporting a beard. To this day Rosi still mistrusts hats and beards but she soon learned to love our friend Charlie.

The real breakthrough came on the Monday after her arrival. My husband was living and working in the city during the week and was coming home at weekends. When Rosi saw him packing that night she freaked, convinced she was about to be moved again.

We had already decreed that her basket in our bedroom was to be a place of safety, never of punishment. I shepherded her there and sat on the floor beside her. Cuddling her, offering reassurance as best I could, I told her repeatedly that she was safe and would be staying here with me. My defences were down; all I wanted to do was to protect this sad, frightened little dog.

It would be wonderful to be able to report that all was perfect from that moment on, but life is rarely so simple. Actually, our first effort as a team was disastrous.

Our home is within sight, sound and smell of the sea. In the interests of walking a straight line, the guide-dog instructors chose the boardwalk running adjacent to the beach for Rosi and I to take our first steps in tandem. When she is nervous, Rosi speeds up; when I am nervous I slow down. As Charles Dicken's Mr Micawber said, 'Result: misery.' My new girl's passion for free running on the beach had not yet emerged, so at least we were spared a tantrum on that score. We didn't fare much better two days later when we walked down what sounded like the street of a thousand dogs, each one intent on out-barking its neighbour and Rosi apparently determined to commune with them all.

The end of the first week, however, brought palpable changes, witnessed and noted by the instructor. It was as if everything somehow clicked into place for Rosi, as though all those months of training suddenly made sense: this was where she was meant to be and what she was intended to do. We found our rhythm, our paces matched, we became a unit. We still took the

occasional wrong turning and succeeded in getting lost a couple of times in those early weeks, but now we were in it together.

On the afternoon of her revelation, my shiny black dog came and sat beside me on the couch—dogs being permitted on furniture in our house. Wrapping my arms around her, I wept into that beautiful coat. 'You're not her, but you're you, and I love you.' I could say it at last. Silly and sentimental, perhaps, to a non-dog person, but a real bonding moment for us, the founding of a glorious partnership that flourishes to this day.

Rosi's personality continued to unfold: her ardent dislike of remote-controlled cars and shopping trolleys, her fascination with cows, her fear of fireworks and thunderstorms. The mutual adoration society she formed with Chris on the first day remains a work in progress. She will perch precariously on his shoulder like an oversized parrot, draping herself around his neck in a parody of a fox fur; or clamber onto his lap and into his arms, tucking her head beneath his chin. It's hard to say which of them looks more smug.

When playing with me, she is gentle and mischievous, but with Chris and Allie there are neither rules nor limits. Rosi has never lost the passion for her work, welcoming any opportunity to show off. Her obstacle avoidance still takes my breath away, though the spring and autumn overgrowth in our area

is often so lush that it is impossible for her to avoid it all. Then there was the day she accidentally joined me in the bath. She jumped up to say hello and was unable to check her forward momentum, a memory that has become one of those treasured 'remember when' family moments, while her insistence on drinking a few drops of the ocean on every beach run is now accepted as a given, a Rosi quirk.

My confession that I did not want Rosi at first did not come easily. Sometimes I wonder if I will ever assuage the guilt.

Elaine Harris

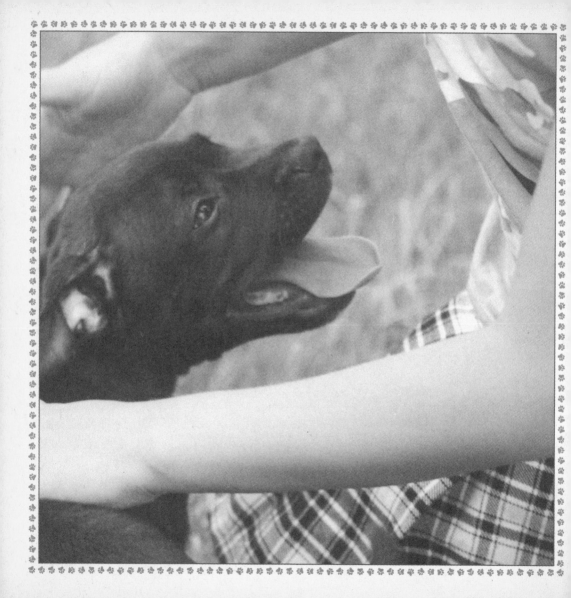

Our Cyclone On Legs

We bought our red Staffordshire Bull Terrier puppy in 2002. He was a bundle of energy and wrinkles with a heart as big as Queensland, and his back legs ran faster than his front legs and would sometimes try to overtake them. Roger has grown up to be a good little bloke who behaves beautifully at home with his family but he goes into maniac mode if we get visitors or take him out of his home environment. There are legs to lick, people to jump up at and personal investigations to complete in as short a time as possible. Hence his nickname, Cyclone On Legs. At home he is sensitive to emotions. If the children are being lectured for misdeeds or a cantankerous computer is being sworn at, he will come and sit at your feet, tail wagging furiously, ears down, imploring you to forgive him on behalf of the children or computer or whatever it is that we are cross about.

As a puppy, Roger enjoyed chewing. Everything. He sampled the back door, the verandah, gumboots and pushbike pedals, and any unsuspecting soft toy was torn to pieces. When he was four months old we had our backyard excavated for a pool. This created a huge pile of rubble and dirt that the kids and Roger found a very exciting play area. One morning, my then eight-year-old son wandered out to inspect the earth works with his small, metal-framed glasses in hand (rather than on his face), as you do. When he returned, he had no glasses and no memory of what had happened to them. He was due at school in ten minutes so we all searched frantically for them, with no luck. I was upset because we had only just purchased them. I had no choice but to take my son to school and gave him strict instructions to sit at the front of the class.

About an hour later I was hanging washing on the clothes line, which was situated next to the excavated pile of rubble, when I felt a presence behind me. Our little bundle of wrinkles walked calmly towards me, sat at my feet and carefully placed a small pair of metal-framed, slobbery but undamaged glasses on the ground in front of me. He looked at me with those pleading eyes and sat quite still.

I was stunned and then thrilled. I lavished much praise and attention on him for his brilliant action. 'We have a genius,' I thought, though my husband later declined my suggestion that he fling his glasses out into the paddock to see if Roger would retrieve them. Probably a wise decision.

Roger has never done anything as impressive as that again but he gives us much love and loyalty despite his cyclonic behaviour. He talks to us in the way only Staffies can. He hides in the car if a passenger door is inadvertently left open, in the hope of a ride. He moves furniture and pot plants rather than walk around them and occasionally runs headlong into the wall or a leg while playing and not watching where he is going. He is a clown and a mate. He is Roger the Cyclone On Legs.

Sue-Ellen Shortiss

Six Months and Already Talking!

Shortly after I had started this book, my beautiful Belle died, and as I wrote in the first story, I found a feather at the exact moment of her death.

At the time I felt that it was truly a message. It was unusually thick and long, in beautiful condition, black and grey and white—like Belle.

After we had buried our beautiful girl and life began again, as it does, it quickly became obvious that the two dogs left behind, Coco and Molly, had lost their leader and they were not the better for it. True, Molly was no longer being bullied every day, but she and Coco both began to show signs of aggression and anxiety around strangers and other dogs, to the point that I began to think my daughter's pleading for another dog made some sense.

And life was so quiet without Belle. Almost too quiet.

I wanted to give a dog a home though couldn't afford to buy an expensive breed, and I was happy to rescue a dog, but from which shelter? And we had

specific needs—it had to be a dog that would settle in with children, horses, the other dogs, and even a cat. Not an easy ask.

One day as I was walking Coco and Molly in the macadamia farm close to where I had found Belle's feather, I asked for guidance on the dog question. I heard, or rather felt, a voice telling me to wait for a feather: a feather would show me the way.

It was such a clear message that the spiritual part of me absolutely accepted it, but the more practical, sceptical side of me strenuously resisted the idea that a feather could have anything to do with finding a dog.

In the end I decided to take the middle ground. Waiting for a feather would buy me the time I thought we all needed to get over Belle's death. If no feather had presented itself by the time we were ready to start looking then I would simply go about getting a dog anyway. (Spiritually practical, that's us Taureans.)

About three months after Belle's death, I took the dogs out, and we were walking up the exact same avenue of trees where I had found Belle's feather when my eye was attracted by a flash of russet on the ground. I reached down and picked up a beautiful little brown, black and russet feather, in perfect condition. Was it the sign? I decided I'd better take it home with me just in case, and popped it into the vase in which I kept Belle's feather.

While I'd been out, Sue, a work colleague, had called and left a message on my phone, even though it was only 7.30 a.m., so I thought I had better ring her straight away in case there was an emergency.

Sue told me a neighbour of hers had to find a home for one Staffordshire puppy left from a litter immediately. The owners lived in an apartment, she explained, and the manager had come down hard on the family that had bred the puppies. All of them had sold except one, and he had to go.

'I know it's an odd question,' I said to Sue, 'but what colour is he?'

'He's black with flecks of brown,' she said. 'I expect he'll be brindle when he grows up.'

'I'll take him,' I said.

Sue was astonished. 'Just like that?'

'Yes,' I said. 'Just like that.'

So that is how Sparky came into our lives—a beautiful brindle Staffy pup with four white socks—but as Anna, my daughter, decided straight away, with far too much personality to be called Socks.

The other dogs were a little wary at first of the small, round, tumbling stranger in their midst. Molly was particularly worried, snarling at him aggressively if he came anywhere near her—I think she thought that perhaps

she was going to be bullied on a regular basis again—but his amazing good nature quickly won them over.

I've never owned a Staffy before, and I am astonished to discover what great dogs they are. People warned me about their energy levels, about their chewing capacity, about the sheer trouble they can be—but Sparky, apart from being a clown, is almost trouble free.

We all quickly fell in love with him, and with his talking!

I had no idea that a dog could be so vocal. At six months he was quite capable of carrying on a five-minute conversation, and I wasn't sure whether to send him to choir practice or teach him a second language.

He is also a 'helpful' dog, and likes to come out with me to the horses, even though his helping usually consists of grabbing their rugs and swinging off them when I'm dragging them across the paddocks (the rugs, not the horses!).

After only a few weeks with us, even though Sparky was then still smaller than the other two dogs, they began to accept him as top dog and, as that happened, they began to relax more around people and other dogs.

Best of all Sparky plays, rather than fights, with Molly, and that has brought out her inner warrior. Now that she's realised it's all in fun, if he gets a little boisterous with her, she grabs his ear between her teeth and bites him, whereupon

he gives a vocal expression of dismay and ratchets down the rough-housing a notch or three.

Unlike Belle, Sparky is a real homebody. He doesn't like to get in the car unless everybody is in there as well, he won't wander too far away from the house, and he's afraid of the dark. He won't come for our late-night wander up the lane; instead he waits under the fig tree until we come back into sight and joins us for the last 100 metres back to the barn where the dogs sleep.

When we walk, he stays relatively close by me, heading off for a quick gambol, but only if I am well in sight.

He comes when he's called. He's learned to sit. He knows the meaning of the words down, stay and drop. He is affectionate, even with the horses, stopping right in front of them to say hello, until they drop their head and touch noses with this odd little creature in front of them.

He fills the gap Belle left. He isn't Belle, but I love him anyway. We all do.

He is Sparky by name and sparky by nature, and he is, of course, a Good Dog and the Best Dog because he is Our Dog.

Candida Baker